IMAGES
of America

FORT MADISON

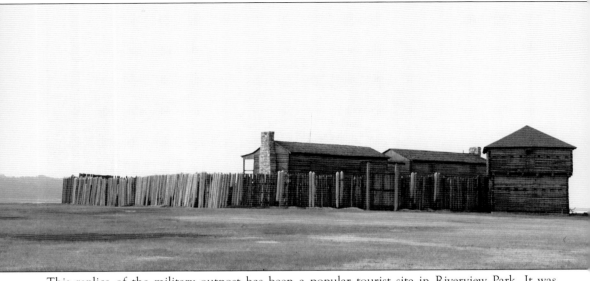

This replica of the military outpost has been a popular tourist site in Riverview Park. It was handcrafted in the 1980s by inmates at the Iowa State Penitentiary (ISP) and local contractors. It represents a portion of the complex that was built in 1808. The original location of the old Fort Madison is under the W.A. Sheaffer Pen Company parking lot next to the Historic Battlefield site. (Courtesy of Kathy Burkhardt.)

ON THE COVER: Posed on Avenue F near the Lee County Courthouse (brick building to left), these men are most likely part of a funeral procession. They are representatives of the hose and ladder companies, so it can be assumed that they are honoring a fireman. Unfortunately, none of the men are identified. (Courtesy of North Lee County Historical Society.)

IMAGES of America
FORT MADISON

Krys Plate and Kathy Burkhardt

Copyright © 2025 by Krys Plate and Kathy Burkhardt
ISBN 9781-4671-6184-8

Published by Arcadia Publishing
Charleston, South Carolina

Printed in the United States of America

Library of Congress Control Number: 2024934666

For all general information, please contact Arcadia Publishing:
Telephone 843-853-2070
Fax 843-853-0044
E-mail sales@arcadiapublishing.com

Visit us on the Internet at www.arcadiapublishing.com

Dedicated to our predecessors who have preserved the history and to those who will continue to protect it for future generations

Contents

Acknowledgments 6

Introduction 7

1. Early Days 9
2. Transportation 25
3. Historic Iowa State Penitentiary 39
4. Buildings and Businesses 51
5. Schools 75
6. Churches and Cemeteries 87
7. Notable Homes 97
8. Around Town 111

About the Organization 126

Index 127

Acknowledgments

We are indebted to our families and friends for supporting us through this journey. Thank you to David Moehn for fact-checking our many details and also to Andy Andrews for sharing his knowledge of Fort Madison's history. Thank you to Kathy Billman for proofreading, fact-checking, and locating photographs and information. We would like to recognize Jim Plate and Jenny Herriman as master proofreaders. Thank you to Sherri Lozano-Dobbs, Angelo Lozano, Cynthia Otte, and Skip Young for sharing their photographs and stories. Thank you to Debbie Moeller for her encouragement and being a wonderful mentor. This book would not have been possible without the resources of the North Lee County Historical Society.

We are grateful to those who have collected and published the stories before us: Ted Sloat, Jerry Sloat, John Hansman, and the *Daily Democrat*, among others. Your commitment to history is appreciated.

As everyone knows, stories can change with each telling. It has been our effort to honor the past and be as accurate as we can. If there is something we have missed or there are errors, we apologize.

This book was written with the intent of creating and sharing a small collection of historical information about Fort Madison. It is our hope that anyone who reads this book will be touched by the stories and remember the unique history of this area. We hope this makes the reader want to know more, and we encourage further investigation. All images courtesy of the North Lee County Historical Society unless otherwise noted.

Introduction

The earliest human inhabitants of the area to become known as Fort Madison were the Mound Builders. They lived in the region around 500 BC and evolved into the Sioux, Sac, Fox, Kickapoo, Ioway, and Illini tribes. The first white men to visit what is now known as the state of Iowa were Father Jacques Marquette and Louis Joliet, who traversed the Mississippi in 1673 and landed near Fort Madison where Montrose is today. A territory of France, this region called "Louisiana" was explored by French cartographer William De L'Isle in 1718. Over the next decades, De L'Isle and several others explored large portions of Louisiana and created extensive maps. Under President Thomas Jefferson, the Louisiana Purchase of 1803 brought more than 530 million acres between the Mississippi River and the Rocky Mountains to the United States territory, including Iowa's prairies and forests. Subsequently, Lieutenant Zebulon M. Pike (using maps created by his French and Spanish predecessors) led 20 soldiers on an expedition to explore the upper Mississippi River. Pike was tasked with finding an ideal location for a military outpost between Saint Louis and Prairie du Chien and obtaining permission from the local tribes to do so. They traveled in a 70-foot keelboat up the Mississippi from St. Louis, enlisting the help of members of the Sac tribe when needed. The group stopped in what would become Fort Madison on August 21, 1805. They also received meat and other provisions from Chief Black Hawk in August 1805. Pike and his men drew maps of the region, which led to the eventual settling of the area. He suggested three different locations for the outpost, and the area to become Fort Madison was chosen.

In 1808, Lt. Alpha Kingsley led the US Army to the area and began construction of the fort. Situated along the bank of the Mississippi River, the fort was comprised of blockhouses, storehouses, and barracks built of white oak logs. Originally called Fort Belle Vue, in 1809 it was renamed Fort Madison in honor of the new president, James Madison. The Native Americans viewed the building of the fort to be a violation of the Treaty of 1804, and shortly after it was constructed Chief Black Hawk led a party of warriors to destroy the fort. This initial effort failed, but after several skirmishes and a battle in 1812 with the Native Americans, the fort was burned down in 1813 by retreating soldiers. This ended the five-year establishment of the fort.

Fort Madison proper can trace its beginnings to the military outpost. White settlers returned to the area two decades later. In 1836, the settled land was small, and log cabins were built in areas cleared of brush and small trees. John Holly Knapp built the Madison House hotel on the site of the old fort, incorporating the remaining chimney. By 1838, the town of Fort Madison had grown to almost 600 residents. It was built on the site of the old fort, and a school district was established in 1840. Fort Madison became a hub of trading and commerce. In 1846, Iowa became a state named in honor of the indigenous Ioway Tribe.

Construction on the Iowa Territorial Prison began in 1839, but the warden's home and the main building were not completed until 1841. Originally built to house 138 convicts, the penitentiary was a work in progress. When Iowa became a state in 1846, the name changed to the Iowa State Penitentiary. Several additions to the complex were built over the years, and when it closed in

2015, the cells housed about 950 inmates and had over 500 staff. The Iowa State Penitentiary at that location had operated for 175 years.

By 1850, Fort Madison's population had more than doubled to over 1,500 residents. Trading posts, hotels, and boarding homes were among the earliest businesses in Fort Madison, with several different companies providing services to the residents. John Cox Atlee built the first steam-powered sawmill in Fort Madison, which processed lumber hauled downriver from northern states. The 1860s brought several businesses, including Valentine Buechel's and Anton Burster's brewery, the Potowonok Flour Mill, and August Schlapp's and August Soechtig's bakery. Following the Civil War, C.E. Morehouse founded the *Evening Democrat*, a local newspaper that is still in circulation today. Bernard Hesse opened a men's clothier in 1879 which operated for well over 100 years. In the 1880s when the population rose to over 4,000, entertainment could be had in the form of roller skating, theater, opera, ballroom dancing, and involvement in numerous social clubs.

Fort Madison resident Judge Joseph Beck, who was known for his kindness and integrity, served on the Iowa Supreme Court from 1867 to 1891. Beck made an important decision for civil rights in 1873 regarding Emma Coger, a lady of African descent. She had attempted to sit at the captain's table on board the steamboat *Merrill*, which was reserved for first-class (or, in other words, white) passengers. Coger was forcibly removed and hit on the head by the captain. Judge Beck ruled in her favor.

The Chicago, Santa Fe & California Railroad built the first Mississippi River Bridge in Fort Madison, signaling the beginning of Old Santa Fe Town in 1888. Freight such as tobacco, lumber, cattle, hogs, and coal were taken to Chicago. People were frequent users of passenger trains as well. The railroad contributed to a significant population increase to 7,900 in only a decade. Mexico's Revolutionary War of 1910 spurred people to immigrate to the area, many of whom became laborers for the railway. These families eventually settled here permanently and brought their cultural traditions with them. They lived primarily in boxcars provided by the railroad, and thus the El Cometa Barrio (between Twenty-Ninth Street and Thirty-Third Street) became the oldest Mexican settlement in Iowa.

The turn of the century saw the downtown area expand along with the population, which numbered 12,000 in 1910. Many family-owned businesses flourished, including Hesse Men's Clothier, Dodd Printing and Stationery, and Dana Bushong Jewelry. The town of Fort Madison is still changing and evolving to meet the needs of its citizens.

One

Early Days

Two decades after the burning of the military outpost of Fort Madison in 1813, settlers came to the area and stayed. Peter Williams is known for being the first white settler in Fort Madison. In 1832, he built a log cabin on the Mississippi River before the land was open for settlement. Soldiers from Illinois demolished the cabin and sent him to jail. He returned only after it became legal. That same year, Gen. John H. Knapp of the New York State Militia settled here. Historians credit him with mapping out the city and naming it after the old fort. Pioneers such as Thomas Fitzpatrick, Amos Ladd, Joseph Webster, and brothers John and Isaac Atlee began developing the town. Knapp's daughter, Amelda Ann Douglass, purchased 79 acres and was one of 38 women who purchased lots.

Much like the United States, Fort Madison is a mixture of different peoples. Among the earliest pioneers were several African Americans, including Elizabeth Green, Lewis Collins, Cy Hubbard, and a man known only as Simon. Unfortunately, not much has been recorded about their history. By the end of the Civil War, many African Americans moved to the area from Kentucky, Tennessee, and Missouri. The Second Baptist Church opened its doors in 1866, meeting their religious needs. Near the end of the 19th century, several African Americans owned successful businesses, including Joe Brown, Press Bannister, and Charles Eubank. Entrepreneurial women of the time included Mollie Eubank, wife of Charles Eubank, who established the first ladies' hair salon in Fort Madison. With the new railroad came an influx of workers from Mexico such as Alfredo Lozano, who eventually settled here with their families. Many of the 1,500 residents of Fort Madison in 1850 were German immigrants. In the 1920s, Fort Madison boasted many breweries and distillery tasting rooms along Avenue H. Most of these were owned by the large population of German Americans, and Fort Madison was known for its excellent German spirits.

Many descendants of the original pioneers still live in the area today including Atlees, Benbows, Harpers, Knapps, Pickards, Rashids, and Rumps.

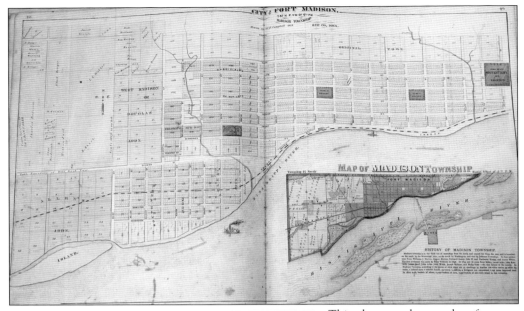

This photograph was taken from the 1874 *Illustrated Atlas of Lee County*. According to the 1872 census, there were "35 dwellings, 35 families, 166 white males, 99 white females, 1 colored male, 1 colored female, 39 voters, 14 militia, 14 foreigners not naturalized, and 1,195 acres of improved land."

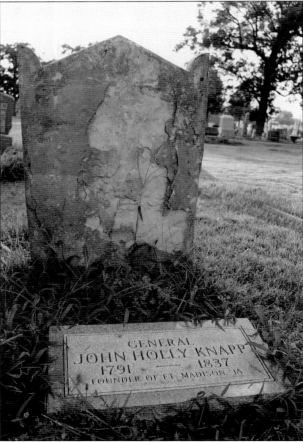

John Holly Knapp arrived in Fort Madison in 1832 and built a hotel on the site of the old fort, utilizing the old stone chimney. He traded with the Indigenous people in the first store in Fort Madison, purchased six acres of land where the Morrison Plow Works was later located, and erected the first horsepower mill for grinding grain in this area. He is buried in City Cemetery.

Pictured with horse and sled is the Honorable Sabert M. Casey (1858–1903). He came to Fort Madison in 1861 with his parents. Casey attended the Fort Madison Academy and was later admitted to the bar on November 1, 1879. He entered into practice with his father. Casey never married and died of Bright's disease at the age of 44.

Hattie Herminghausen was born in 1857 in Fort Madison. She worked in Burlington to learn her trade, then opened her own shop in Fort Madison. Her business was located at 718 Avenue G, and she employed several women to help make hats. She was so successful that she built a home at 517 Avenue H. She never married.

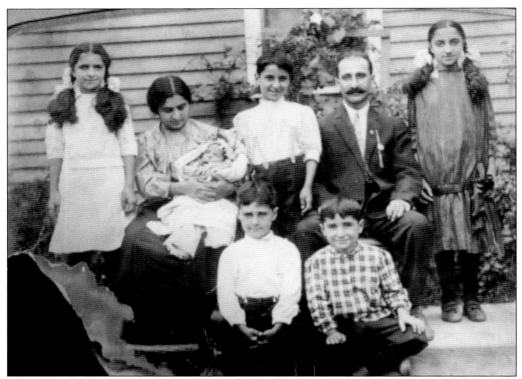

The Rashid family has been in Fort Madison since 1901, when Jacob and Saida opened a dry goods store called West End Cash Grocery Store. Originally from Lebanon, the couple first settled in Illinois and then South Dakota. From left to right are (first row) Ferris and Idol; (second row) Edna, Saida, baby Frank, George, Jacob, and Mary. Mary opened the Economy Department Store in the 1930s. (Courtesy of Inez Pothitakis.)

John Cox Atlee started Atlee Lumber Company in 1852 with his brother Isaac. When Isaac retired in 1853, John partnered with Nathaniel Bennett and built the first steam-powered sawmill in Fort Madison. Eventually, his son Samuel (left) joined him at S. & J.C. Atlee Lumber Company and became manager. Samuel was president of Lee County Savings Bank when it opened in 1888. (Courtesy of Sarah Maize Sherman Hirsch.)

A.J. BENBOW

Wood and Coal

1006 FRONT ST.

Offce Phone Bell 517-J

Residence 929 Fourth St.
Bell Phone 192-M

Alfred Benbow was born in 1862 in Burlington and later came to Fort Madison. He founded and ran the Benbow Coal Company until his death in 1935. He married Emma Okell in 1888; they attended the First Methodist Church and had four children. They lived at 929 Avenue E. He is buried in Elmwood Cemetery. This advertisement is from the 1916 city directory.

H. F. BENBOW

Ice, Coal and Wood, Hay, Grain, Seeds and Feed of All Kinds

ICE — The only ice dealers in the city that always bring their supply from the Illinois side of the river. Their service is first-class; place your order with them and you will be sure of a supply that will last through the whole season.

HARD COAL — Give them your order for COAL. They handle only the best LeHigh Valley Hard Coal.

SOFT COAL — In Soft Coal, they handle Roanoke, Charter Oak, Diamond Block, Peerless Block, Brilliant Block and all of the best quality, well screened Illinois Coal.

WOOD — You can buy from them the best of hard wood at reasonable prices, as they draw their supply from their own tract of timber located near the city. Also all kinds of hard-wood lumber and wagon materials, axles, tongues, bolsters, etc.

All business entrusted to them will receive careful attention, as they always maintain enough competent men and teams in active service to handle their business promptly and successfully.

TELEPHONES: BELL 64-J; RES. PHONE 186-Y

Horatio Frederick Benbow (brother to Alfred) was born in 1856 in Salt Lake City, Utah. After coming to Fort Madison, he ran the Ice, Wood, and Coal business at 225 South Locust Street with his brother, Edgar. Edgar lived at 1717 Avenue H, formerly his grandparents' home. Horatio died in 1924 and is buried in Elmwood Cemetery.

Peter Miller came to Fort Madison in 1836 and married Pamela Kellogg. Miller started the first blacksmith shop in Fort Madison. In 1846, he was elected sheriff of Lee County, and in 1868, he built a sawmill and started a lumber business. Chief Black Hawk gave the Farewell Speech in 1838 from Miller's vineyard. Miller's sons, John and Charles, began the Miller Brothers Tent Show in 1904. John married Ella Burgett, and they had one daughter, Anna. Their shows traveled to several different states. The show tent held 1,200 people. Below is Anna decked out in her patriotic costume in front of the Miller Brothers tent. Anna went on to teach Latin for over 40 years at the Fort Madison High School. Over 20 Millers are buried in City Cemetery.

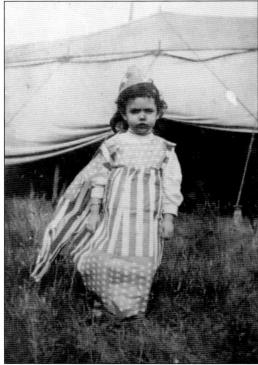

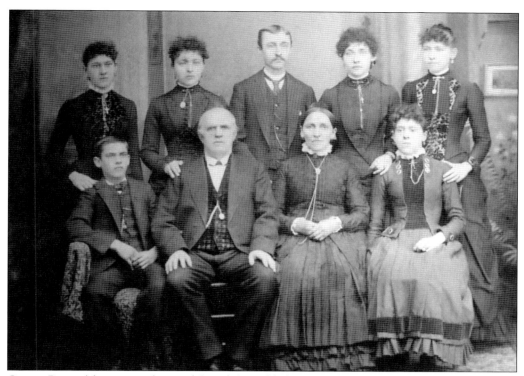

George Rump (above, seated second from left, and below, seated second from right) and his family are pictured decades apart. George Rump was born in Lee County in 1842. He worked as a clerk in a grocery store in Saint Louis, Missouri. Rump returned to Fort Madison at age 19 and opened a dry goods and grocery business at 1436 Fourth Street. After two years he formed a partnership with his father-in-law, H.E. Borchers. They combined their stock and ran the business together until 1857. Rump bought out the business and moved it to 715–717 Second Street (Avenue G), where it remained until 1900. He served six terms as city treasurer. (Both, courtesy of Kathy Burkhardt.)

Sisters Sophie and Marie Zumdome married brothers Clem and Henry Peterschmidt. At left are Sophie (1876-1940) and Clem Peterschmidt. Below are Henry and Marie (born in 1868) Peterschmidt. Clem worked at the Morrison Plow Works and was the lone survivor in a tragic boating accident in 1896. Four men were in a skiff when they lost an oar and capsized. In 1920, he was a grinder and lived in La Crosse, Wisconsin. Henry and Marie stayed in Fort Madison after marrying and had nine children. He worked for the railroad as a truckman and also as a day laborer.

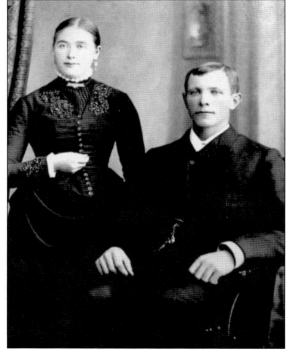

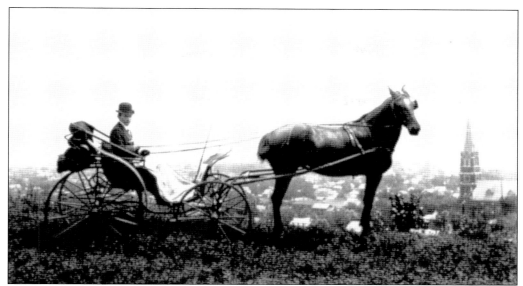

Dr. William Kasten, pictured above with his horse, was born in 1877. He attended Keokuk Medical College. He loved playing around with his camera and took many photographs of his family and friends. Kasten married his first wife, Florence Mae Deal, in 1903, and they had a son, Kenneth William Kasten, in 1913. They divorced, and she and Kenneth moved to Los Angeles to live with her sisters, Elizabeth and Jane. Kasten then married Margarita Atlee, whose brother happened to be Samuel Atlee. Her parents were Isaac Atlee and Lucy Reynolds Atlee. Dr. Kasten died in 1950. Below, Florence Mae Kasten is second from left.

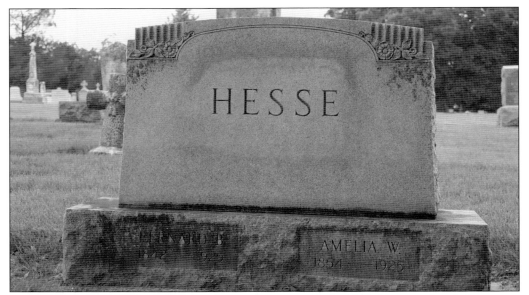

Bernard Hesse Sr. (1842–1929) trained as a tailor at age 13. In 1879, he opened a clothing store known as B.B. Hesse and Sons, which ran until 1995. It was the largest distributor of clothing and furnishing goods in Lee County. They also sent mail orders out west and gave a five percent discount for cash. Several generations of Hesses worked at the store. (Courtesy of Kathy Burkhardt.)

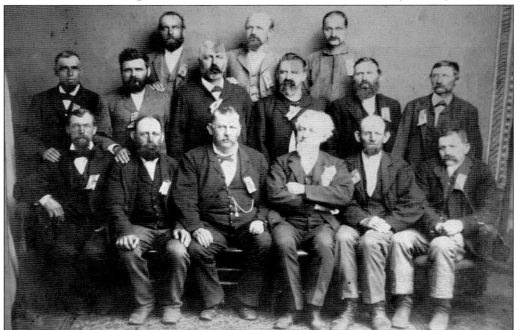

Iowa Fifth Regiment Company F Iowa Volunteer Cavalry held a Civil War Veterans reunion on June 18, 1885. From left to right are (first row) August Schubert, C. Stauffer, August Schlapp, Lt. John A. Smith, unidentified, and Fred Becht; (second row) unidentified, Sgt. Henry Schlapp, C. Ende, Robert Scholz, Cpl. Frank Wagner, and Trooper Westphallen; (third row) unidentified, Color Sgt. August Soechtig, and Trooper Vanoter. Most of these men were German immigrants.

John D. Pickard was born in Indiana in 1840. He enlisted in Company "D" Division Seventh Iowa Volunteer Infantry in 1861. Pickard served under Ulysses S. Grant during the Civil War. His company traveled the river in steamboats and attacked the Confederate-fortified town of Columbus, Kentucky. He helped capture Lookout Mountain and was later wounded in the knee. After the war, he returned to Fort Madison.

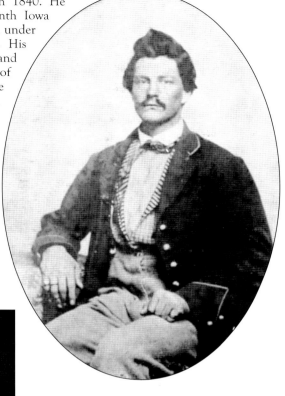

The Old Settlers Association began in 1871, with Phillip Viele serving as the first president. Members paid a secret amount in dues to join. A total of 512 members signed their names and the dates of their arrival to the area, which had to be prior to July 1840. The first annual Old Settlers Fourth of July celebration was held, with Daniel F. Miller giving a lengthy address. (Courtesy of Kathy Burkhardt.)

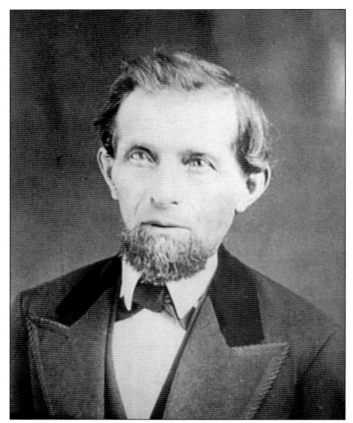

Born in 1817 in Germany, Conrad J. Amborn moved to Fort Madison and became a master woodworker. Most notably, he built and carved a bedroom set for Judge Joseph M. Beck in 1860. The photograph below shows the remarkable detail of the headboard. He also carved the semi-circular walnut teller's desk in the German-American Bank (701 Second Street). After his shop closed due to competition from other local manufacturers, he worked for the Atlee Lumber Company in the millwork department. He was married to Louisa, and they had four sons. They lived at 720 Second Street (Avenue G). Amborn died in 1899 and was buried in City Cemetery.

Dr. Isaac Galland (1791–1858) was active in several towns, including Fort Madison, Montrose, Keokuk, and Nauvoo, Illinois. He was a medical doctor and helped plat out the streets in Keokuk. He later became a lawyer and edited and published a newspaper. He married Nancy Harris in 1811 in Ohio, Margaret Knight in 1815, Hannah Kinney in 1826, and Elizabeth Wilcox in 1833. Galland was an elder in the Latter-day Saints but withdrew by 1843. He built the first school in Iowa, Galland School. In all, Galland had four daughters and a son. His most notable daughter, Eleanor, was the first Caucasian child born in Lee County. Eleanor is pictured below with her mother, Hannah, and brother Washington.

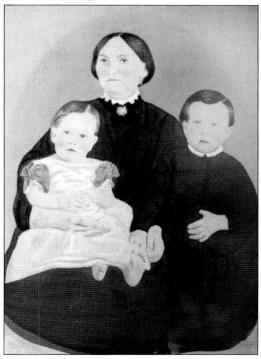

Ernest Corsepius (1868–1934) came to Fort Madison in 1901. He was the owner and operator of a tractor supply company and the Fort Madison Ice Company, one of the city's several ice businesses. Corsepius's ice buildings could house 18,000 tons of ice. About 250 men were employed for seasonal work. In 1914, he was president of the Commercial Club, which had about 100 active members.

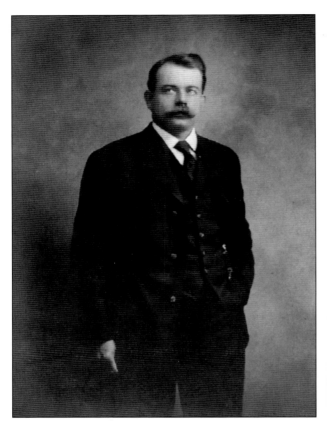

Pictured in his Fort Madison Fire Department uniform is Louis Albers. Born in 1883, Albers also worked as a city clerk for 34 years and owned a grocery store south of the Boss Hose Company Number Three located at 111 Walnut Street (Tenth Street). He was secretary for the volunteer Boss Hose Company. He is buried in Gethsemane Cemetery.

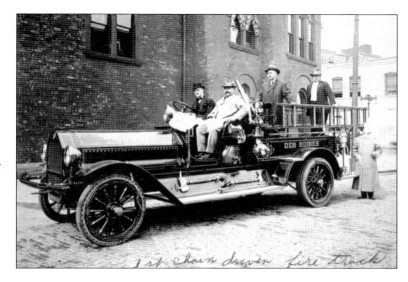

This photograph from 1917 shows the first-ever chain-driven fire truck in Fort Madison. It was purchased as a used vehicle. The first three men, left to right, are Councilman John Oppenheimer, Mayor M. Collins, and city clerk Louis Albers. The other two men are unidentified. (Courtesy of Wendell J. Fish.)

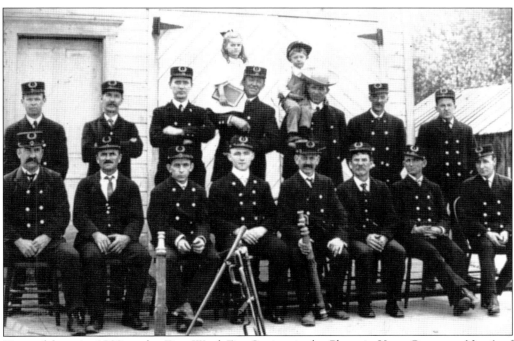

Pictured here in 1908 at the First Ward Fire Station is the Phoenix Hose Company No. 1 of the Fort Madison Volunteer Department. From left to right are (first row) Henry Taylor, James Atchison, John Parker, George Luegering, William Marsh, Henry Funkauser, Edward Daley, and James Gollinger; (second row) John Gerveler, William Zimmerman, Frank Pruellage, Alfred Carback, Frank Culp, and Edward Wallis. The children are Madelene Culp and Eddie Wallis.

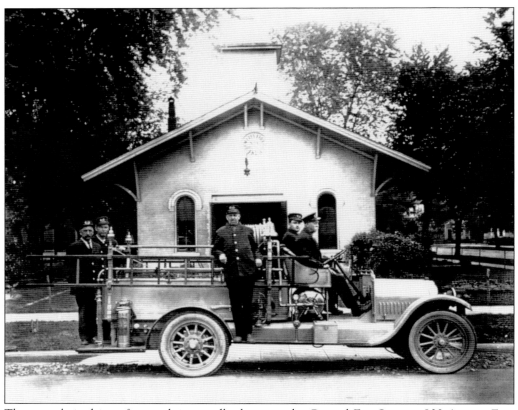

The new chain-driven fire truck is proudly shown at the Central Fire Station, 803 Avenue E in 1917. The building was constructed in 1861 as City Market and purchased for $500 around 1873. It had housed the Silsby steam fire engine, which could pump water from the river or from cisterns built to furnish water for fighting fires north of Avenue E.

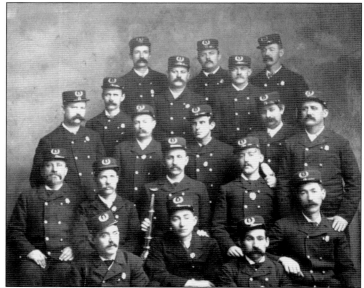

Pictured here is the Boss Hose Company No. 3, which was located at Tenth Street above Avenue F. Prior to 1887, volunteers pumped water from either the river or cisterns built in 1874. Once the city purchased a fire engine in 1913, east-end volunteer companies were dissolved. Unfortunately, none of the men in the photograph have been identified.

Two

TRANSPORTATION

Fort Madison has a long history of riverboat and railroad transportation. The year 1865 signaled the first year that trains went through Fort Madison. Construction on the Fort Madison and Northwestern narrow-gauge railroad began in 1871, which later became known as the Peavine. Local men John Cox Atlee, Captain Davis, Charles Doerr, E. Gibbs, and John Van Valkenberg organized in the early 1850s to secure a government charter for building a bridge across the Mississippi at Fort Madison. Their efforts came to fruition in 1888 with the completion of the Santa Fe Bridge, which was replaced in 1927 when the new bridge was finished. The new Santa Fe Bridge is also known as the Mississippi River Bridge and the Fort Madison Bridge. In 1900, unskilled laborers for the railroad earned $1.15 for working a nine-hour day. By 1911, Mexican contract laborers earned $1.51 a day.

There have been many other modes of transportation that have been popular as well. Trolleys, buses, barges, ferries, and automobiles were just a few of the ways goods and people moved throughout the area. Aaron White ran the first ferry to Fort Madison in 1834 across the Mississippi. Simpson White and Amzi Doolittle took over in 1840 and transported goods and people across the river. They connected horses to a treadmill which powered the paddle wheels. For a man and his horse, the rate was 37.5¢, with each additional horse being 25¢.

Early efforts to make Fort Madison streets easier to travel backfired. They used yellow clay to pave the streets in 1867, but the roads became a slippery mess after it rained. In 1883, Second Street (Avenue G) was paved with cobblestones, but those, too, had their problems. After the population boom that came with the Santa Fe Railway, many of the streets were paved with brick in 1888. Many of these streets still have brick pavers to this day.

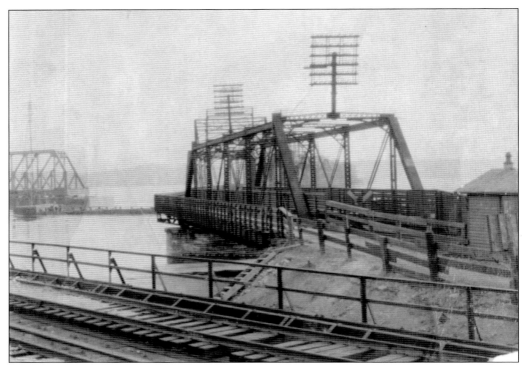

What came to be known as the Santa Fe Bridge opened in 1888 and crossed the Mississippi River from Fort Madison, Iowa, to Illinois. The swing span bridge was built as a single-level bridge which allowed one train to cross at a time. There was a road and walkway for one-way traffic that crossed the bridge on each side of the train tracks. The bridge was rebuilt to the current standard from 1925 to 1927 and is still the longest double-deck swing span in the world, measuring about a mile. The bridge allows two-directional train traffic below and automobile traffic above. The photograph above shows the old bridge while the photograph below depicts the new bridge, which is in the National Register of Historic Places.

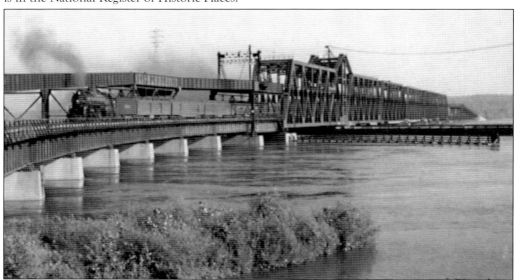

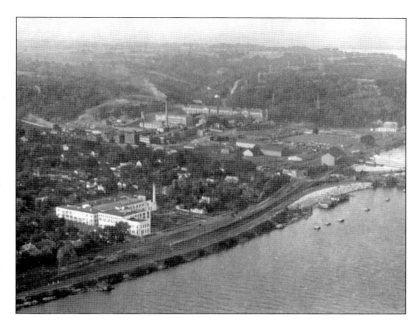

This view of the railroad tracks shows the area in 1925 before the building of the new bridge. The white building in the foreground is the W.A. Sheaffer Pen Company complex. The Iowa State Penitentiary is seen in the middle towards the back. The small marina is on the right. Note all the trees along the riverfront where Riverview Park is today.

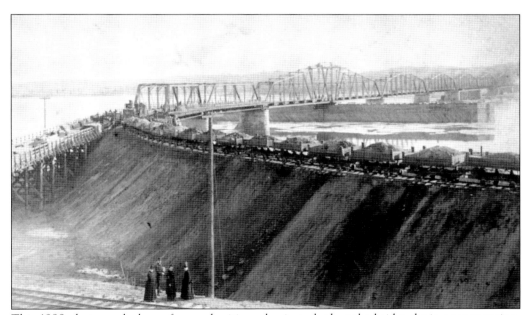

This 1888 photograph shows four early citizens having a look at the bridge during construction. The gondola rail cars are loaded with fill ready to dump on both sides of this track. One can see how the bank is being filled in. The tracks in the lower left corner are the Chicago, Burlington, and Quincy line that runs along the riverbank.

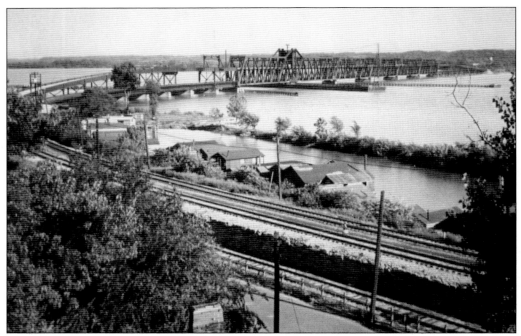

This unique vantage point showcases the new bridge sometime after 1927. What looks like flooding is actually the marina, lined with fishing shacks. The raised railroad tracks are the Santa Fe tracks which go across the bridge to Illinois, while the tracks down below in front are the Chicago, Burlington & Quincy tracks that stay on the Iowa side.

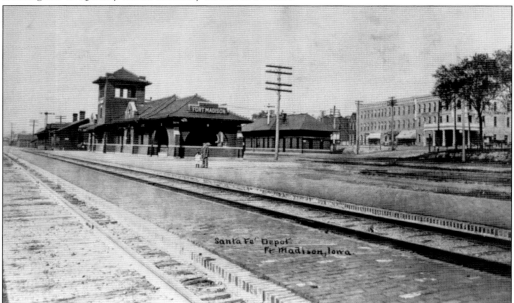

This unidentified man and child wait for the train to arrive. The Santa Fe Depot is pictured here perhaps in the early 1900s looking west, prior to the area being filled and Riverview Park being constructed. The large building on the right is the Anthes Hotel. Doodlebug tracks not visible here dead-ended at the Santa Fe Depot.

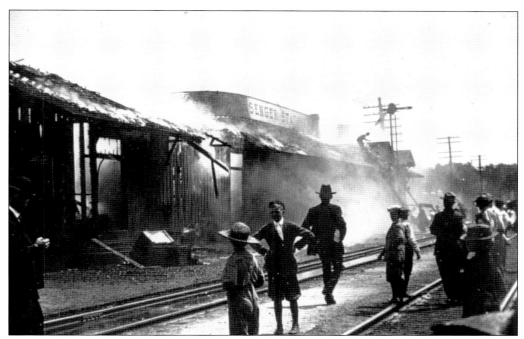

The west end of the Santa Fe Depot (built in 1887) was destroyed by fire in 1909. The wooden structure housed the freight office. It was replaced in 1910 after the old one was torn down. The new depot was built in the mission style and operated as a depot until 1968. It currently houses the Amtrak Station and part of the North Lee County Historical Society Museum.

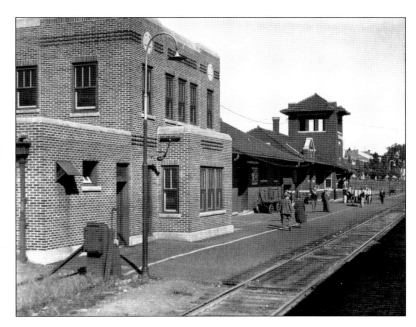

This photograph, taken by Frank Ellington in the 1940s, shows the back side of the Division Freight Office building and the 1910 Santa Fe Depot. The freight office was built in the 1930s after several buildings were destroyed by fire. Later, the current railroad station platform, walkway, and wall were built.

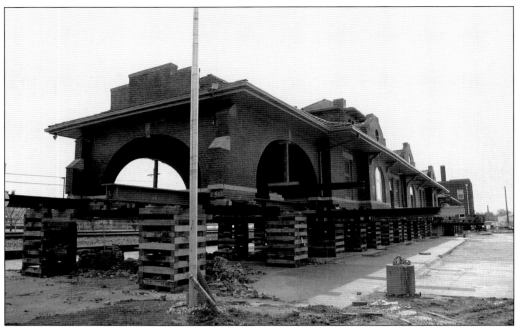

The raising of the depot complex in 2011 cost $4.5 million and was paid for with several grants, including money from the city. Three brick buildings (the Railway Express Agency building, the Division Freight Office, and the Santa Fe Depot) were raised and four feet of concrete foundations were added. The depot has flooded more than once, most notably in 1993.

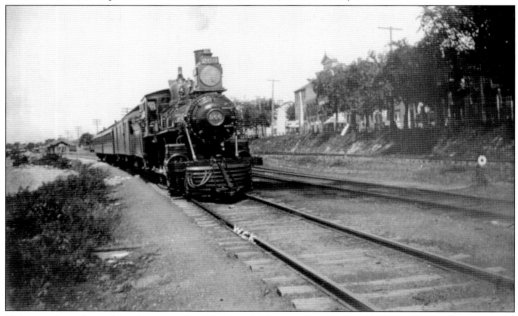

Using a glass plate, this photograph of Engine 266 was taken by Dr. William Kasten. To the right of the 1890s engine, the Fort Madison downtown area can be seen, with the top of the Ebinger Grand Opera House visible if one looks closely. The highest set of tracks on the right went to the Morrison Plow Works.

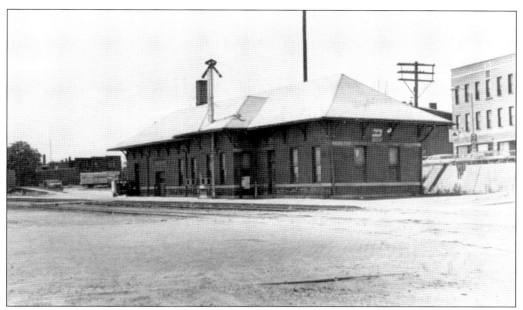

The Chicago, Burlington & Quincy Depot was built and opened in 1898. This building is the second depot that was located here for passengers to purchase train tickets. The last tickets were sold in 1968. The building is currently used as part of the North Lee County Historical Society Museum. Owned by the railroad, tracks in front are used for coal and freight transportation.

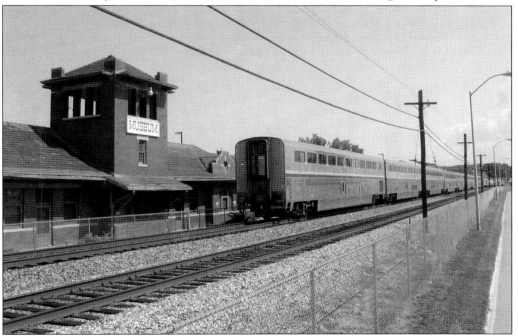

Fort Madison's Amtrak passenger service was relocated to the east end of town in the historic 1910 Santa Fe Depot in 2021. The passenger lines now run from Chicago to California and back, stopping twice per day in Fort Madison. This photograph shows a passenger train from around the 1970s, prior to the platform being built.

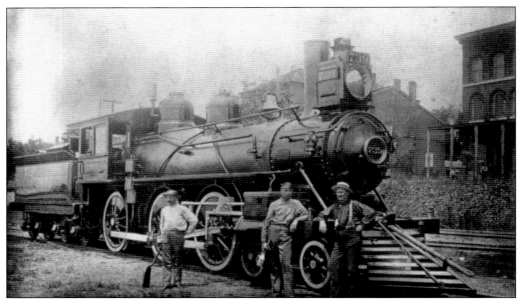

East of the depot is Santa Fe Railroad Locomotive No. 739. It was built in 1891 by the Schenectady Locomotive Works in Schenectady, New York. Pictured on the left holding a shovel is the fireman, in the middle with the oil can is engineer Orson Furze, and on the right is probably the conductor.

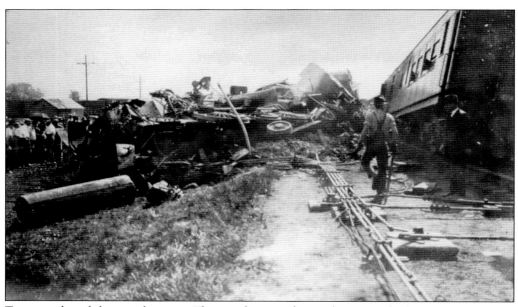

Train wrecks, while rare, do occur. This one happened near the east end of town in June 1922. Two Santa Fe trains collided, resulting in two deaths: the engineer and the fireman of one of the trains. Fourteen passengers were injured. Oddly, the locomotive not seen in this photograph had a similar accident in the same spot just three years prior.

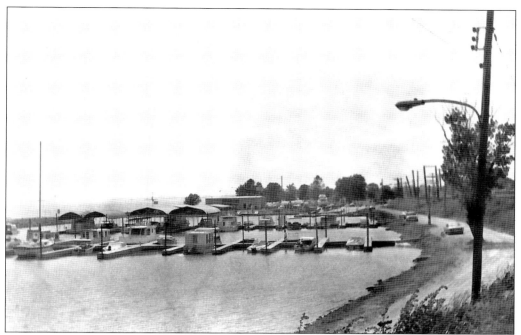

The marina west of the bridge has been renovated many times. In the late 1800s, Sherm Winters taught kids how to swim in the river near here. In the late 1940s, the first breakwater was installed. This photograph shows the marina area around 1960 after two long docks were added. The most recent renovation began in 2022 and was still going on at press time.

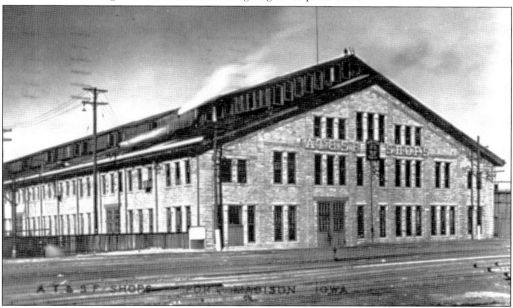

Pictured around 1940 is the largest of the back shop buildings in the Santa Fe yards, which enclosed a complete machine shop. The yard had over 20 tracks for railway cars which were repaired or rebuilt here. In 1906, about 850 men were employed, including 500 in the yards and mechanical departments, 100 engineers, 100 firemen, and 40 conductors.

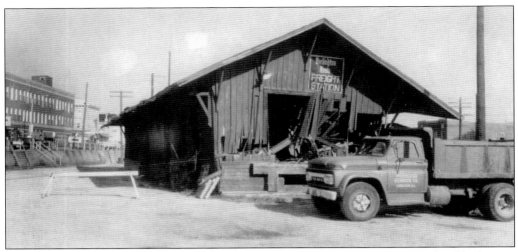

The first freight house had an enclosed water tower used for filling steam engines. The old Chicago, Burlington & Quincy freight house pictured above was demolished in 1970 because it was no longer used as a depot. Peerless Service Company assisted in the demolition. Visible to the left is the Anthes Hotel.

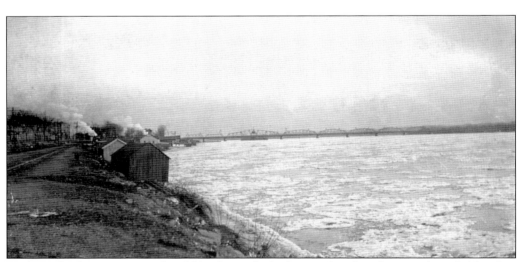

Looking closely, one can see the old bridge in the background in this photograph probably taken from a glass negative. In the foreground are fish houses where the day's catch was processed. Notice the Diamond Jo warehouse behind the fish houses. Most of these structures were torn down when the Keokuk Dam was built due to the increase in water levels.

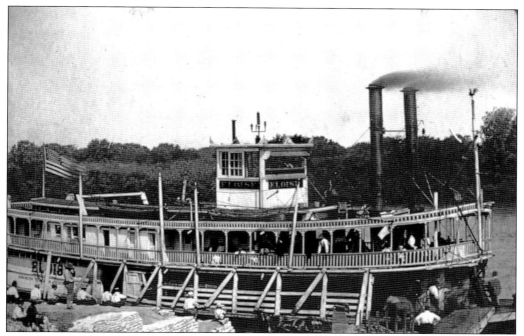

Prior to the railroad coming to the area, steamboats were a predominant form of transportation. The steamer *Eloise* was built in 1888. Seen here near Fort Madison, she ran between Burlington and Keokuk daily. In the early 1900s, *Eloise* stopped in Fort Madison at 8:00 a.m. going north and 5:00 p.m. going south. *Eloise* was part of the Northwestern Transportation Company.

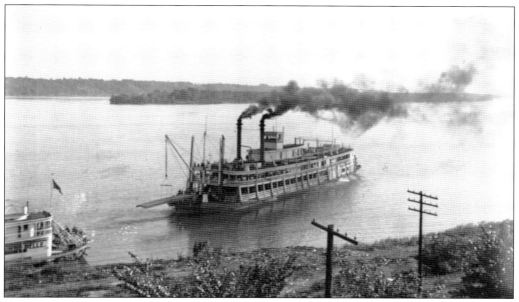

The *Ottumwa Belle* (left) and the steamer *Dubuque* getting ready to dock in Fort Madison. The *Dubuque* ran for the Streckfus Steamboat Line and started its trip in Keokuk. She then cruised to Hamilton, Nauvoo, Montrose, Fort Madison, and Burlington, before heading back to Keokuk. Rates were 50¢ for adults and 25¢ for children around 1920.

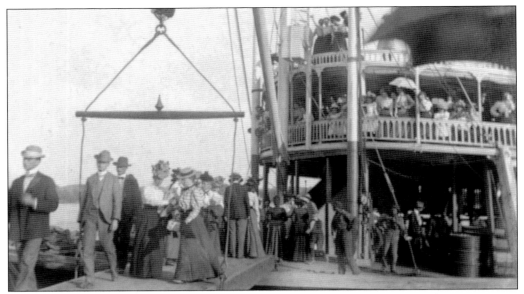

Ladies and gentlemen in their finest are seen here disembarking from an unknown steamer. Riverboats provided popular summer excursions, which could last most of the day. Boats would stop at various locations along the river and riders would have the opportunity to stroll along the riverfront, shopping or simply enjoying the day.

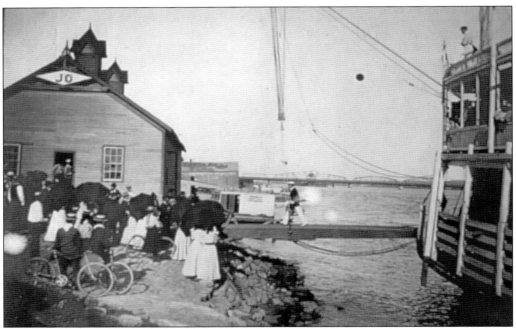

Located at the foot of Sixth and Front Streets, the Diamond Jo was one of the largest steamboat lines on the Upper Mississippi. Steamboat packet lines such as Carnival City, Diamond Jo, Northern, and White Collar once connected cities along the Mississippi River. White-banded smokestacks indicated a steamer was part of the White-Collar line. Churches and other groups would often rent out an entire boat for excursions.

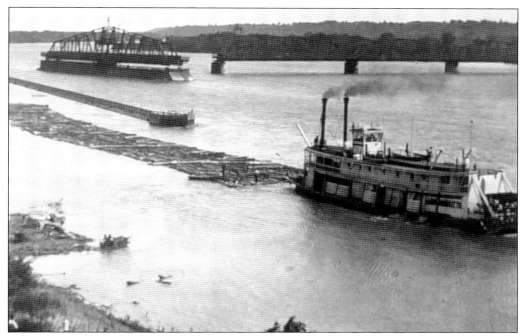

Prior to 1916, this unknown paddlewheel steamer is pushing a log raft downstream behind the shear boom for protection. Local lumber companies would often use steamers to push log rafts to locations on the river. The shear booms were removed each winter and set up again each spring. Notice the bridge is open for boats in the background.

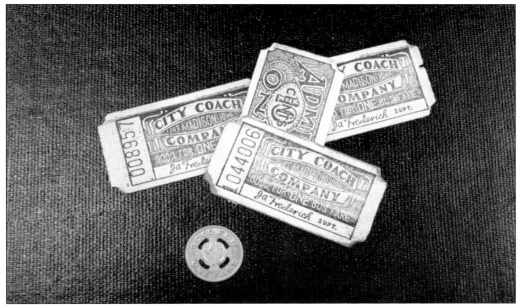

The Mississippi Valley Transport Company added a bus to their streetcars in 1924. It ran along Avenue E every 30 minutes. By 1930, this "City Bus Line" replaced the trolleys with 10 new buses painted yellow with red trim. Bus fare was 10¢ for adults or 16 tickets for $1. Shown here are a token and tickets, worth one fare each. (Courtesy of Kathy Burkhardt.)

In 1887, the Fort Madison Street Railway Company had four miles of track from the prison to Peake's Amusement Park, now known as Ivanhoe Park. The Orient Line went to the prison. Trolleys were originally pulled by mules and ran on tracks. The mules had individual bells and citizens would know which trolley was coming by the sound of the bell. In 1895, the green and orange trolleys were converted to electric power provided by the Fort Madison Electric Light and Power Company. Below, the Harper Building can be seen behind the trolley. The trolleys ran until 1929 when they were replaced by buses.

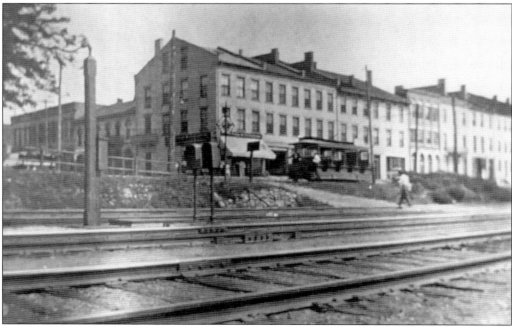

Three

Historic Iowa State Penitentiary

The Historic Iowa State Penitentiary is one of the oldest prisons west of the Mississippi River. Construction began in 1839 when citizens donated 10 acres of land to build the prison and $40,000 was appropriated for the construction. It was built to house men who had been convicted of the most serious crimes: murder, rape, or horse thievery.

Women have been a part of the penal system since the early days. Records show that a female prisoner was housed in Warden William Anderson's home in 1855, and she lived there with his family. Women's quarters were not arranged until 1877, when the top level of the warden's home was designated for women prisoners. By 1897, all women had been transferred to the new prison in Anamosa.

The first manufacturing done in the prison began in 1849 under A.W. Haskell, and the business was a cooperage, which made wooden barrels. Later, other industries were added, such as a chair factory, leather works, shoe factory, and desk manufacturer.

Warden Percy Lainson initiated reform during his tenure, including improving prison food and utilizing inmates where they were most useful. When he retired in 1958, his successor (warden John Bennett) continued his work.

Minimum-security prison farms were started as a method of rehabilitation. At one point, there were three farms as part of the system. In the early days, inmates worked on the farm and provided vegetables, milk, and eggs for consumption by the prisoners. In 1963, almost 36,000 gallons of vegetables were canned by Farm Three inmates. Over the years, inmates tended thousands of chickens, a dairy herd, and multitudinous fruits and vegetables. Eventually, the farms were phased out of the prison system.

The inmates were moved to a new facility in 2015. The new prison was built over the old farm No. 1 and is called the Iowa State Penitentiary. Patti Wachtendorf became the first female warden in Iowa in 2017. Wachtendorf brought back prison gardens, where inmates grow their own food, coming full circle.

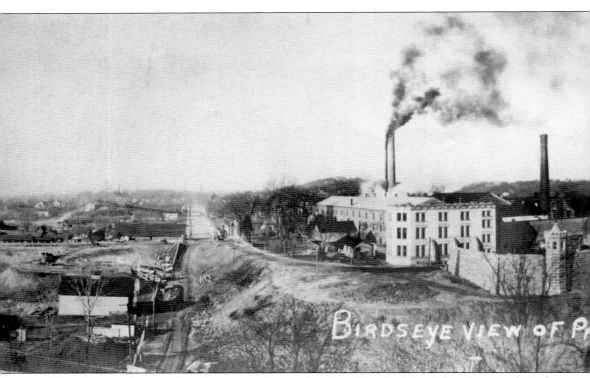

This photograph was taken from an unknown location. On the left of the photograph is the warden's house, which is facing the river. July 1839 saw the beginning of the building of the 60 prisoners' cells, an outer wall, and the warden's house. William Anderson was the first warden, and prisoners were stored in the cellar of the warden's house in a cell accessed through a trap door

for safekeeping during the night. Seven of twelve inmates had escaped by fall because the building was incomplete. Once it was finished in 1841, the facility cost around $55,000 and could house 138 inmates.

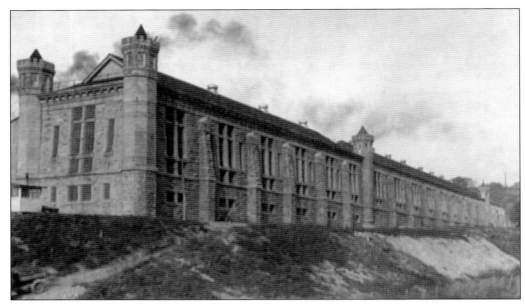

This is an early picture of Cell Block 18. Inmates at the penitentiary built this cell block from 1920 to 1924. The first electric lights were installed in 1886, primarily to light up these walls. They were locomotive headlights, each fitted with a 32-watt bulb, and the electricity was generated by a steam-powered Dynamo.

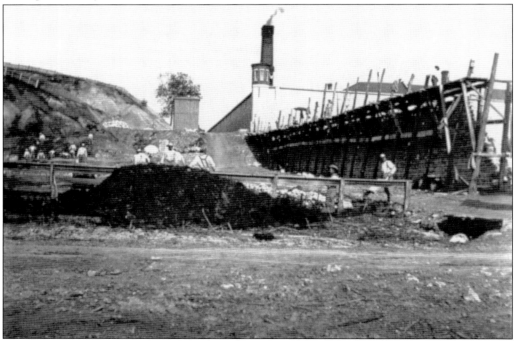

These men are working on the construction of the wall. Note the striped pants, circa 1910. In the 1840s, inmates were required to wear uniforms made of two-sided cotton bed ticking. The early 1900s brought uniforms that were earned. New inmates received stripes, and after three months of good behavior, they moved up to checkered suits.

In 1878, the Fort Madison Chair Company contracted inmate labor to construct chairs. Women were paid 10¢ per chair to cane them at home. A fire that began in the paint shop building of the chair industry destroyed the chair industry and adjoining buildings in 1922. In the foreground is the Industries Control Office.

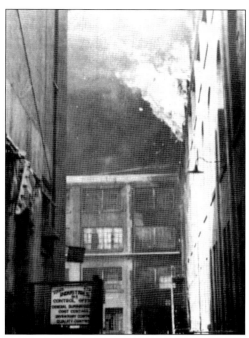

Julius L. Hesse was an Iowa State Penitentiary guard pictured here in 1910 wearing his guard uniform. He lived with his wife, Pauline, and their two daughters on Second Street (Avenue G), close to the prison. The family moved to Lincoln, Nebraska, in 1913, where he worked for the Nebraska State Prison.

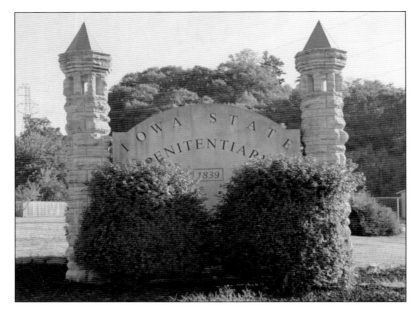

The Iowa State Penitentiary was built in 1839, as can be evidenced by this sign, which echoes the guard towers. Built of limestone, it was originally known as the Iowa Territorial Prison because Iowa was not a state but had become a territory in 1838. It is now called the Historic Iowa State Penitentiary. (Courtesy of Kathy Burkhardt.)

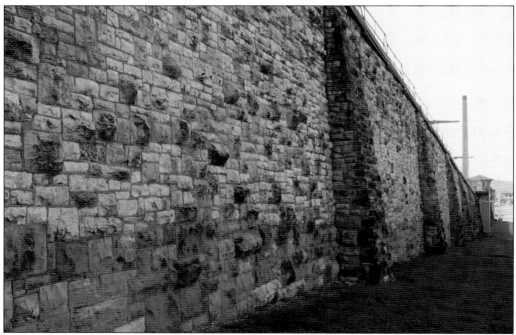

These are the original penitentiary walls made of local limestone hauled in from the quarry in Appanoose Township, Illinois. Built to hold the men at the maximum-security prison, the walls are between four and five feet thick. The thinnest point is the walkway at the top. Decommissioned in 2015, it was the oldest continuously run prison west of the Mississippi. (Courtesy of Kathy Burkhardt.)

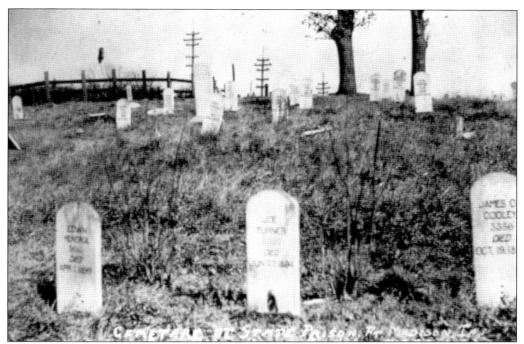

Some of the earliest inmates were buried at the old Iowa State Penitentiary Cemetery, where 67 inmates were interred (above). The remains were moved to a new site when the prison was expanded (below). Prior to 1872, executions were carried out in the county of prosecution. When the law changed, executions were carried out at the penitentiary. The first execution at the Iowa State Penitentiary was that of James Dooley. He was hung on October 19, 1894, and was buried in the prison cemetery. The last execution in Fort Madison was that of Victor Feguer in 1963. The death penalty was abolished in Iowa in 1965. (Below, courtesy of Kathy Burkhardt.)

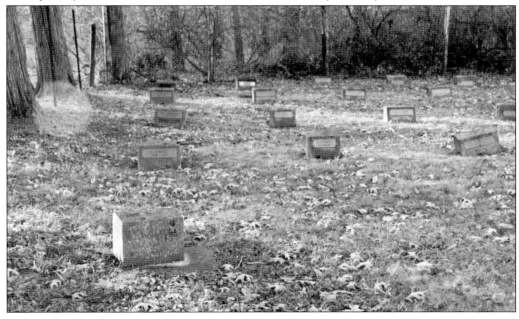

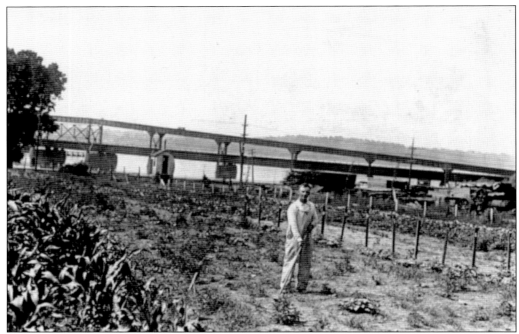

In this undated photograph, an unidentified man is working the garden. Early on, prisoners' meals consisted of bread, meat, potatoes, a few vegetables, and very little fruit. Prisoner supplies were bid upon by various vendors and then brought in. Inmates grew vegetables for use at the prison in this eight-acre plot.

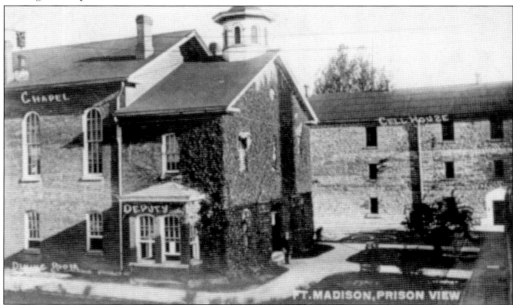

This chapel, even though it looks small, could seat over 300 people. Prisoners were encouraged to attend Sunday services and got credit for "good time" if they went. This is the original cell house that is on the registry. The chapel was upstairs, and the dining room was on the first floor under the chapel.

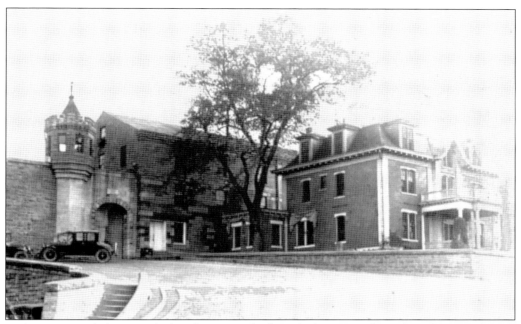

Built in 1840 and photographed in the 1920s, the "Warden's Mansion" faced south. It was directly attached to the prison wall. The unseen house to the right was the deputy warden's home. When John Bennett was promoted from deputy warden to warden, he chose to not move his family to the bigger house. These buildings have since been torn down.

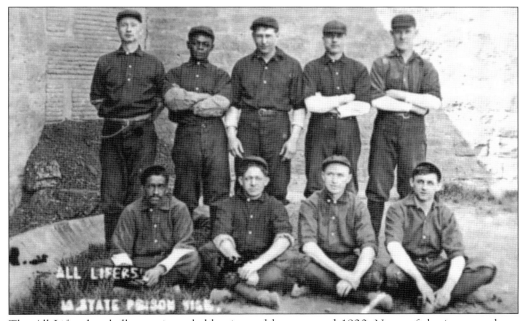

The All Lifers baseball team is probably pictured here around 1920. None of the inmates above have been identified. In the 1930s, the *Presidio* (the prison newspaper) contained many articles about the "A" team, the Prison Blues. Other sports teams included softball, basketball, and football. The 1938 Fort Madison Bulldogs football team was unscored upon and undefeated.

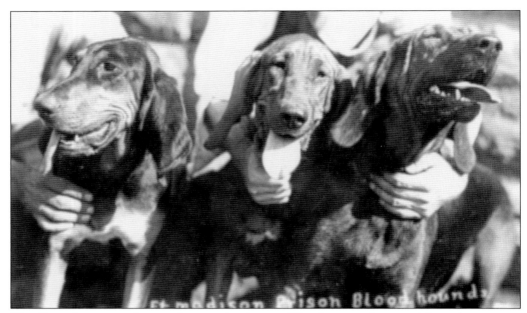

Bloodhounds were used to track escaped prisoners. The dogs were borrowed from Anamosa or Mount Pleasant, but the trail would be cold by the time the animals were transferred to Fort Madison. The penitentiary guards got their own pack of 42 bloodhounds in 1925. The dogs were in use for about 10 years. Oddly, the bloodhound became the Fort Madison High School mascot.

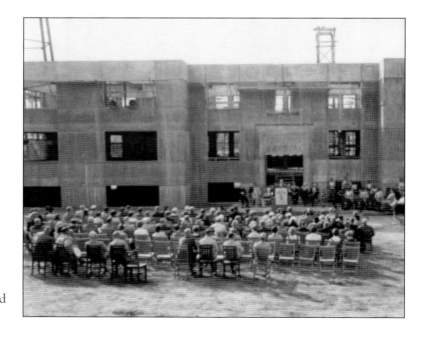

The new Feightner Hospital was dedicated in 1957. Officers and inmates elected to name the new hospital after Dr. Robert Feightner, chief surgeon for a number of years. Music was provided by inmates via the Bob Frost Band and the Iowa State Penitentiary Choir. Gov. Herschel Walker spoke, as did Warden Percy Lainson. This hospital was replaced in 1984.

At left is the John Bennett Correctional Center, a medium-security unit. It had 169 beds and was named for warden John Bennett, who served under Percy Lainson. Bennett succeeded Lainson, who was known for having brought about much reform. The Lee County Health Department is currently located there. At right is the cell block. (Courtesy of Kathy Burkhardt.)

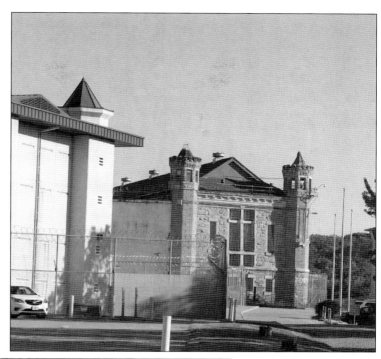

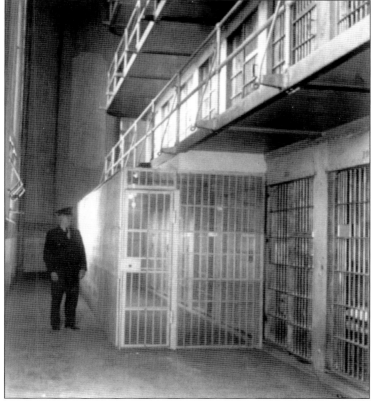

An unknown guard stands by a newer cell block. Historic Iowa State Penitentiary was modeled after the Auburn, New York Penitentiary. It was basically a prison contained within a prison and had a cell for each prisoner. Old Cell Block 217 is unusual in that it looked like there were three stories from the outside, but it actually had four stories of back-to-back cells.

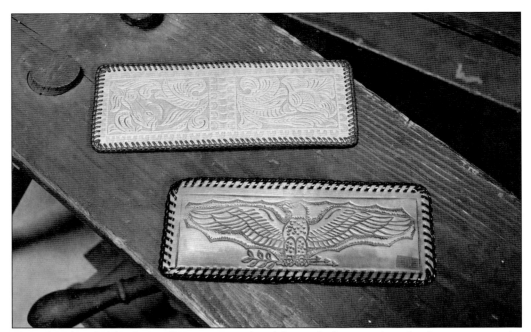

These hand-tooled leather wallets are a sample of the work that was done by the inmates in the prison industries. Men would learn a trade as they worked in the various shops. The industries included a chair factory, leather works, an automotive shop, a woodworking shop, and a desk manufacturer. (Courtesy of Kathy Burkhardt.)

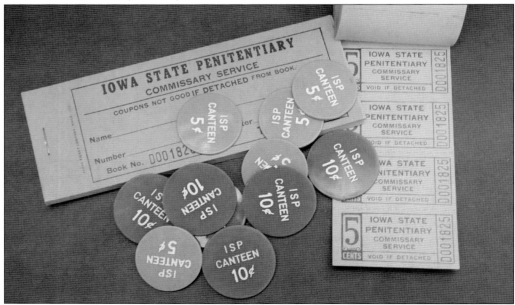

These tokens and tickets were intended for use at the ISP commissary. Inmates could earn the tokens and utilize them for any number of sundries. Note the 5¢ and 10¢ amounts. The tickets in the booklet were not valid if they were torn out; prison employees had to do the tearing. (Courtesy of Kathy Burkhardt.)

Four
Buildings and Businesses

Fort Madison is and has been home to many businesses of all kinds. The oldest known business was established in 1840 by Conrad Schaper and was known as Schaper's Meat Market. His son, Frederick Conrad Schaper, took over the business, which was run by a Schaper for almost 100 years. In the early days, there were six ice companies that harvested ice from the river, including the Artesian (founded by A.P. Brown, John Larson, and a third partner) and the Fort Madison (purchased from H.A. Einspanjer and Sherm Winters by Ernest Corsepius).

Many businesses were kept in the family over several generations, including Dana Bushong Jewelry, Dodd Printing and Stationery, Faeth's Cigar Store, Hesse Men's Clothier, Schaper's Meat Market, and others.

Women in business in the early days included Hattie Herminghausen (millinery), Mollie Eubank (hair salon), Lizzie and Catherine Bruegenhemke (millinery), and many others. Dr. Mary Geiser came to Fort Madison in 1894 and served as the first woman doctor here. In 1952, a large article in the *Evening Democrat* highlighted over 50 area women involved in local businesses. Today, there are undoubtedly countless more women involved.

Many banks have survived the years, including Fort Madison Bank and Trust, Fort Madison Savings Bank, and Lee County Savings Bank.

The Fort Madison Downtown Commercial Historic District was listed on the National Register of Historic Places in 2007. Because the river flows from east to west in Fort Madison, the city's downtown area is on the east end of town. Most of the buildings exhibit the Federal, Italianate, Renaissance Revival, or Romanesque Revival architectural styles.

The motto of Fort Madison is "The city with a future," and with so many old and new businesses in the area, it certainly has staying power.

The Anthes Hotel (Avenue H and Ninth Street) began operation in 1846 with 20 rooms. It had 72 rooms in 1907 and was managed by William Henry Atlee. George Anthes was the proprietor and Charles Anthes was the manager prior to 1927. Owner Edward Boss updated the hotel in 1938, putting in air conditioning. The building was razed in the 1980s to make room for a parking lot.

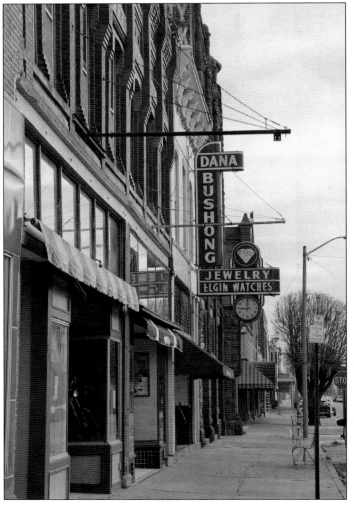

Dana Moser Bushong worked for W.A. Sheaffer Pen Company before opening Dana Bushong Jewelry (805 Avenue G) in 1922. Nine-foot-tall jewelry cases from Shaeffer's were hauled by trolley down the middle of Avenue G. The storefront was removed to fit them in and put back. Bushong was well-known for his incredible engraving skills and was featured in the 1937 *Ripley's Believe It or Not!* (Courtesy of Kathy Burkhardt.)

Cattermole Memorial Library (614 Seventh Street) boasts both Loire Chateau and Richardsonian Romanesque styles. Elizabeth Cattermole donated $30,000 toward the building of the library in 1893 as a memorial to her husband, Henry. Cynthia Albright, with a salary of $35 per month, was the first librarian. This building is in the National Register of Historic Places and is home to offices and apartments.

Built around 1916, the Densmore Franklin Andrews building (1828 Avenue L) housed a mercantile and dry goods store and had a gas pump out front. Dennis Andrews and his wife, Luella, raised eight kids in the apartment upstairs and ran the store until the 1930s. Once, a love letter was found in a crack in the plaster. Descendants of Andrews still live in the area. (Courtesy of Kathy Burkhardt.)

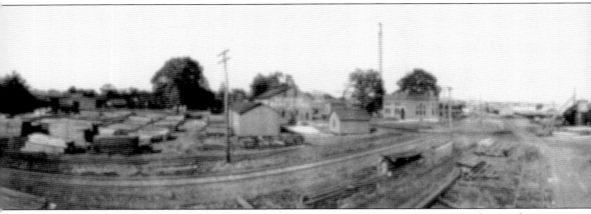

The Atlee Lumber Company was a leading Fort Madison industry and one of the first in the area. John Cox Atlee opened the lumber yard in 1852 with his brother, Isaac, who retired in 1853. The business eventually became known as S. & J.C. Atlee Lumber Company. The mills encompassed a 35-acre complex and, by 1870, processed 55,000 feet of lumber per day. Trees were felled in

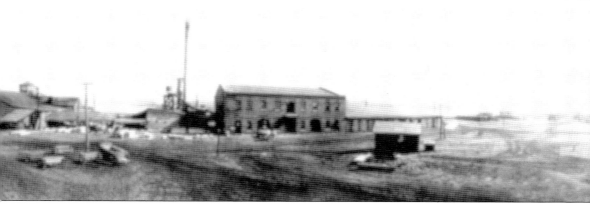

Minnesota and brought south by riverboats such as the *Ottumwa Belle*, a steamboat owned by Atlee. The mill employed over 300 men during the sawing season. Loggers were paid $40 per month, including room and board. Several women were also employed as clerical workers. Due to deforestation, the last lumber raft arrived at the bank of the Mississippi in 1915.

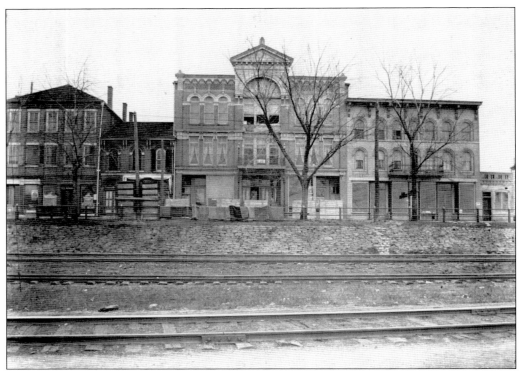

The Ebinger Grand Opera House, 735 Front Street (Avenue H), was owned and managed by Edward Ebinger. Originally at that location was the Bennett Roller Skating Rink, which burned in 1870. The Ebinger was built in 1872–1873 and opened in 1873. It later became the Grand Theatre, then the Columbia Theater in 1922, and finally, the Iowa Theatre in 1934. It was eventually razed for a city parking lot.

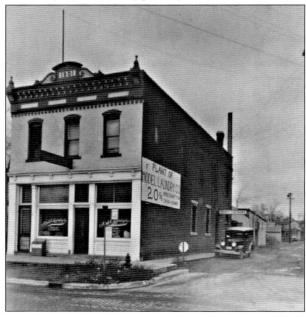

This building was erected in 1901 at 2501 Avenue L. The Model Laundry moved here in 1918. This photograph was probably taken in the 1930s, around the time it was owned by Albert F. and Ray B. Wiebler. A 20-percent discount for cash and carry customers was offered when it was common for laundry to be delivered. This location is currently the Two Rivers Bank drive-up.

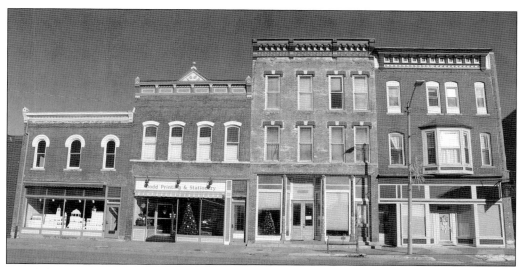

Established in 1877 as Pythian Printing, the firm owned by Hyempsal Williams Dodd Sr. was located in the Lincoln Hotel. In 1908, Hyempsal W. Dodd Jr. relocated to 621 Avenue G (second from left) as Dodd Printing. Now known as Dodd Printing and Stationery, it has been an icon for decades. The business remained in the Dodd family for four generations. (Courtesy of Kathy Burkhardt.)

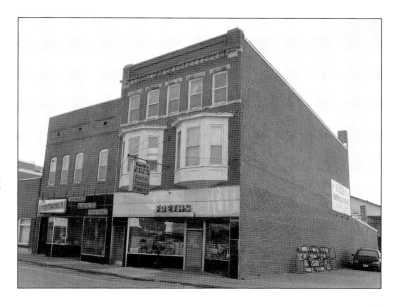

Faeth's Cigar Store (832 Avenue G) was originally a pool hall owned by William R. Faeth. He started the business in 1926, and it has been run by the family ever since. After Prohibition Faeth's sold beer. Later many other items including candy, ammunition, and tobacco products were added. Interestingly, the Art Deco serving bar came from the 1934 Chicago World's Fair. (Courtesy of Kathy Burkhardt.)

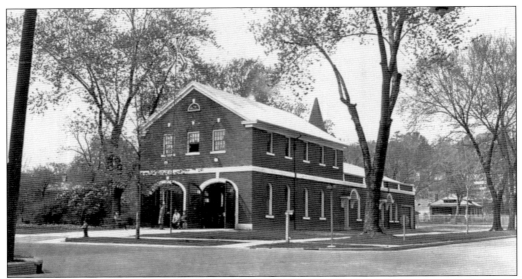

Originally owned and built by Amos Ladd, the East End Fire Station (811 Avenue E) served the east side of town. Ladd, a local mason, also built the courthouse and the Iowa Territorial Prison. The city spent $500 in 1873 to purchase this property, which housed two fire trucks for several years before being closed due to budget cuts. Firefighters were then transferred to the West End Fire Station.

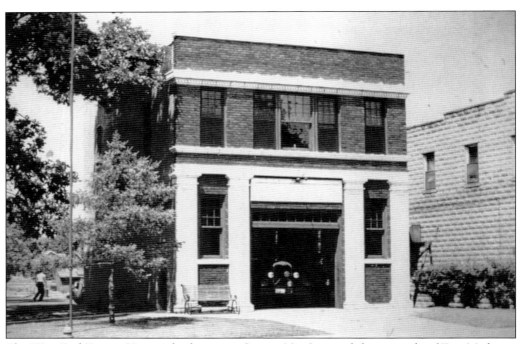

The West End Engine House, also known as Station No. 2, served the west side of Fort Madison. It was built in 1917 at the corner of Santa Fe and Madison Avenues (Avenue L and Thirty-Sixth Street). A brass pole was installed so the men could quickly get downstairs. This building was replaced with the new west-end fire station at 2335 Avenue L in 1959.

The Osbourn family posed in 1917 in front of the Florence (712 Ninth Street). Built in 1856 by J.D. Eads, it began life as a hotel and home. In 1866, it became the Fort Madison Academy. After 1887 it was sold several times and was known as the Hotel Florence, the Lee Hotel, and the Lincoln Hotel. Its life ended when it was destroyed by a 1973 fire.

The Fort Madison Chair Company operated out of the Iowa State Penitentiary starting in 1875. Located in Buildings 1, 2, 15, and 16, the company made wooden chairs like the one above using inmate labor. Around 200 inmates worked in this industry and built around 600 chairs per day in the 1880s. A fire swept through the industry in 1922, destroying everything.

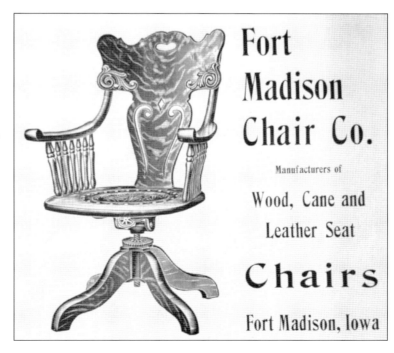

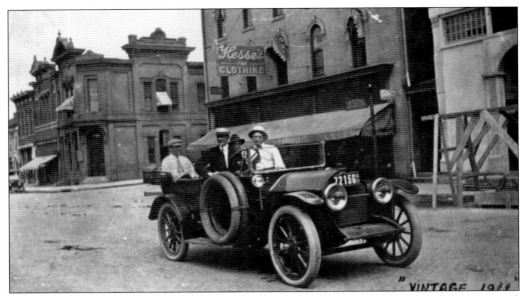

These men appear ready to shop at Hesse Men's Clothier in 1911. Across the street (701 Avenue G) was the German-American Bank, founded by Henry Cattermole, his cousin Arthur Cattermole, and brother-in-law H.D. McConn in 1876. Conrad J. Amborn, master wood carver and furniture maker, carved the semi-circular walnut teller's desk. During World War I, the bank's name was changed to the American State Bank. The bank closed during the Depression.

This is the 500 block of Avenue H. The Second Empire home on the left, built in 1898, was owned by Hattie Herminghausen, milliner. The Italianate middle building, erected in 1859 by John Able, held his grocery business on the first floor and home on the top two floors. The building on the right was constructed in 1857 by Peter Miller. Peter Amborn operated his confectionery there in 1868.

Pictured here is an H.G. Haessig advertisement from 1906. Henry G. Haessig was the owner of this establishment at the corner of Second and Chestnut (835 Avenue G) that made and sold cigars. Haessig started out in L.B. Reader's cigar store, then bought Charles Jones's business and made it his own. Haessig's descendants still live in the area.

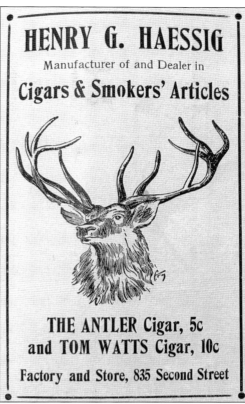

This building at 631–635 Avenue H has been home to many businesses. Built in 1845 by Guy Wells, it was home to the Albright Dry Goods store in the 1870s. It was purchased in 1930 by Dr. Harry Harper and used as a residence and medical offices for himself and his brother, Dr. George Harper. It eventually became Harper Apartments and was razed in the early 1990s.

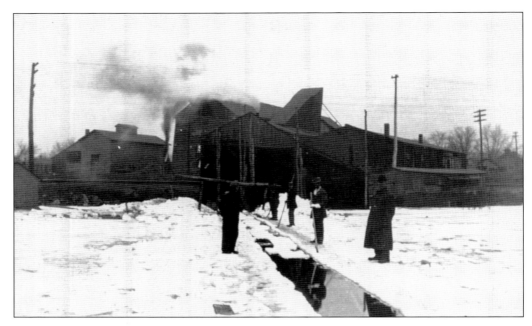

As early as the 1880s, Thomas Smith was harvesting ice from the river. Ice was cut using large saws, and blocks were dragged to the bank by horses and loaded on freight cars. Ice was stored in warehouses and insulated with layers of sawdust. Alfred Benbow started the Benbow ice-cutting business prior to 1900 and was one of six such businesses in the area. Ernest Corsepius purchased the Fort Madison Ice Company after he moved to Fort Madison in 1901. His yearly ice harvest was shipped to St. Louis and other cities via train. Eventually, these companies were put out of business with the advent of artificially produced ice, which was advertised as "pure."

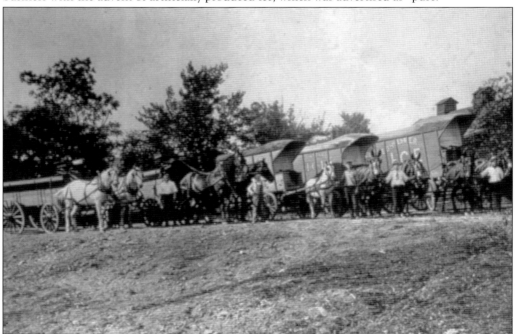

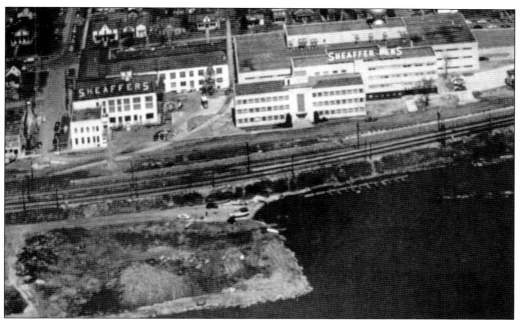

The small building at left is part of the site of the 1808 original Old Fort Madison. In 1836, John Holly Knapp opened the Madison House there. In 1874, Dennis and Joseph Morrison built the Morrison Plow Works factory and moved their business there. The W. A. Sheaffer Pen Company moved to this location after the plow works closed in 1917. The curved path between the buildings was a railroad spur used for moving farm implements. Everything to the left of the spur has been demolished for an employee parking lot. In the 1942 photograph below, men are changing part of the factory from producing pens to manufacturing military hardware, contributing greatly to the war effort. Items produced included rapid radio frequency changers. This plant employed 2,740 people in 1945 and closed in 2008.

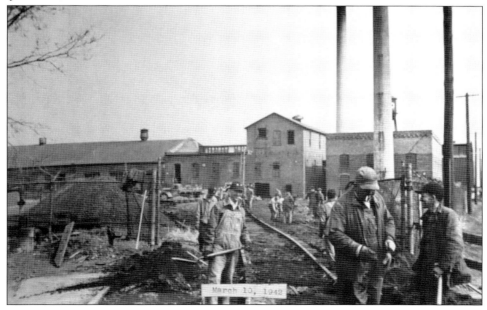

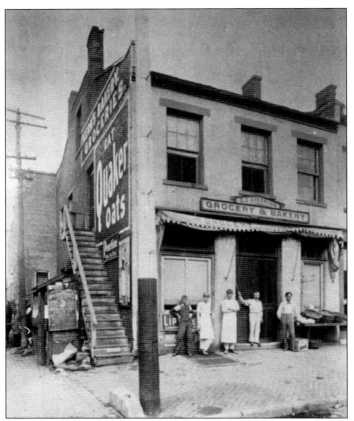

The building at left (115 Pine Street) was owned by August Schlapp and August Soechtig. They opened a bakery in 1866 but sold it to the G.D. Diedrick Grocery and Bakery. Diedrick then sold it to William Kern in 1897, who held a grand opening on July 1, 1888. The building changed hands several times over the next few years, being sold to Christian Hartman in 1900 and then to John Larson in 1906, who operated it as a bakery until 1938. This Kern Bakery should not be confused with the Kern Bakery below, which belonged to William Kern's brother, Peter. Located at 1102 Avenue E, this building was built in 1888. Peter and his wife, Catherine, lived in the apartment upstairs. (Below, courtesy of Kathy Burkhardt.)

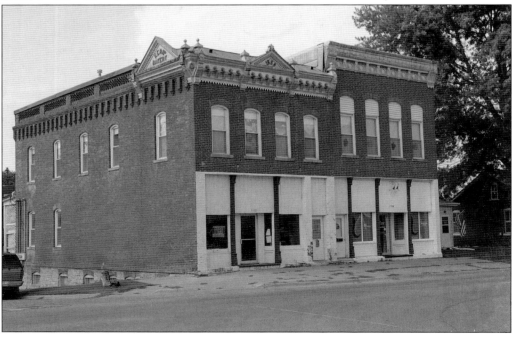

This 1953 photograph features the Bernard Hesse Sr. building (Sixth Street and Avenue G). The first floor consisted of a clothing store with its own tailor, the second floor held the W.A. Sheaffer Pen Company factory, and the third floor had a ballroom. The building currently houses businesses on the first floor and apartments on the second and third floors.

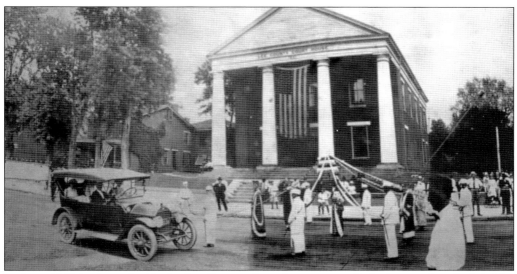

Built in 1841 by Amos Ladd, the Lee County Courthouse originally had a cupola, which held a bell. The bell was rung to summon volunteer firefighters. Ironically, a 1911 fire took its toll on the building. The courthouse was restored to its original Greek Revival style but without the cupola. Seen here decked out in patriotic, 1916-style regalia, the Tuscan columns are clearly visible.

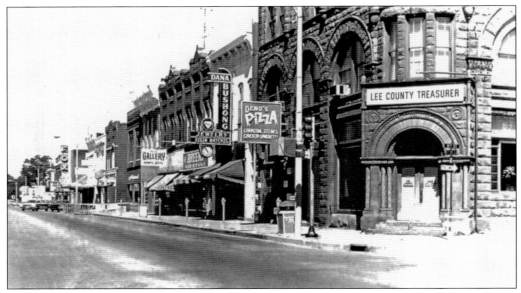

This is the 800 block of Avenue G looking west. From east to west are the Lee County Treasurer's Office, (originally Lee County Savings Bank), Deno's Pizza (owned by Deno Constantine and managed by his brother Dionysus Constanopolis), Dana Bushong Jewelry (owned by Elizabeth Bushong), Breen's News Stand (run by Rita V. Breen), Gallery Imports and Gift Shop (run by Mike Wedel), and J&S Office Machines.

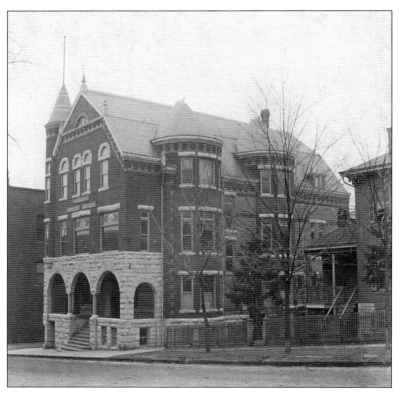

Named for Jacques Marquette, the Marquette Building (607 Eighth Street) was built in 1895 by physician Dr. Downs and used as a rental property. The town was booming due to the coming of the Santa Fe railroad and housing was needed. They held a parade of pigs for the grand opening of the building. The third floor had an auditorium with a stage. (Courtesy of Kathy Burkhardt.)

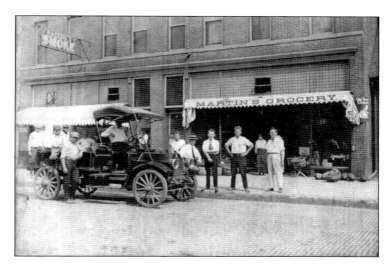

In front of Martin's Grocery around 1912 are, from left to right, Mr. Johnson, Mr. Schmidt, Mr. Jones, Mr. Williams, Ab Schulte, and Mr. Borgman. The men with the car are unidentified. The grocery was owned by Allen C. Bayles and Clarence C. "Chum" Martin. The grocery at 833-835 Avenue G had previously been H.G. Haessig as well as a pool hall.

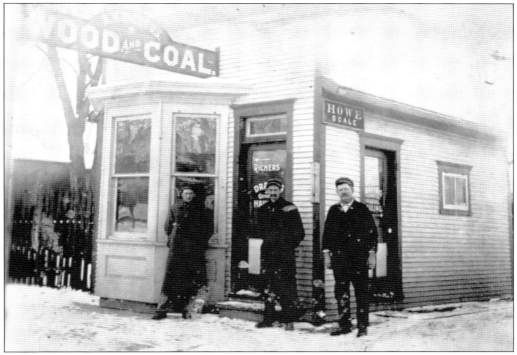

The August W. Richers Wood and Coal Company is pictured here around 1917. The business was located at 508 Second Street. Richers was a guard at the Iowa State Penitentiary for 13 years prior to his death. The family also at one time had an ice business and a trucking business. He also was a drayman and delivered items. Richers had nine children, many descendants of whom still live in the area. (Courtesy of Darrell and Jan Richers.)

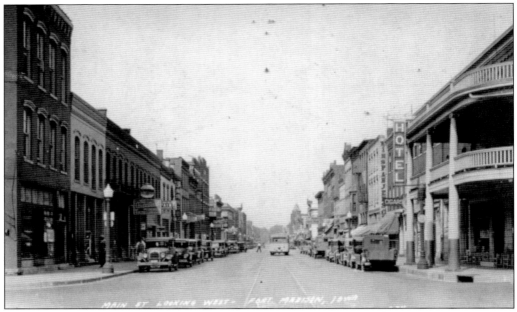

In this 1938 photograph, one can see down Avenue G looking west. On the right at 601-607 is the old portion of the Metropolitan Hotel (with railing), 609-611 is the new part of the Metropolitan, next is Einspanjers Grocery Store, then Dodd Printing and Stationery at 621. At left a paint store and Ford dealership are visible.

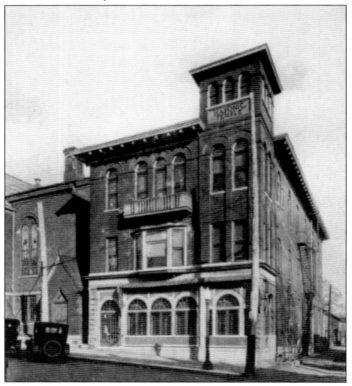

The Masonic Temple building at 614 Eighth Street was the home of the YMCA from 1897 to 1910. Officers of the YMCA Auxiliary included Mae Kasten (secretary) and Charlotte Atlee (president). The building was built in 1895 for a cost of $18,000. The building is currently home to Temple Apartments and has changed little over the years.

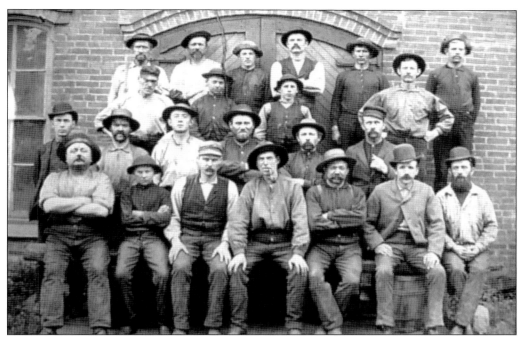

Employees of the Morrison Plow Works posed in front of the factory in 1886. Samuel Morrison opened the plow manufactory in 1854. During the Civil War, all four of his sons fought for the North, so the plant was closed. In 1865, Dennis and Joseph re-opened the plow works with their father. The company was sold in 1908 to J.A. Samuels. Samuels operated the plant as the Fort Madison Plow Works with his sons. The plant did a large export business and closed its doors in 1917 due to the outbreak of World War I. It later became the W. A. Sheaffer Pen Company.

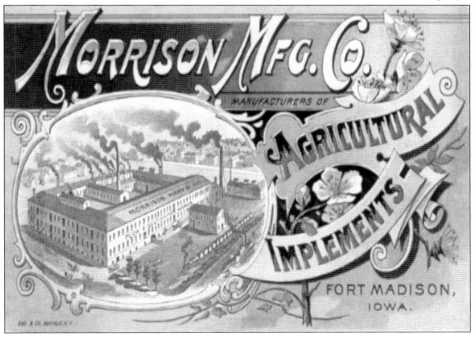

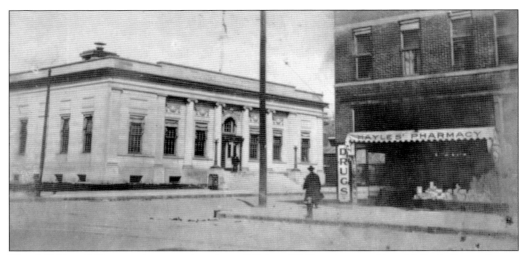

This US Post Office was in operation from 1914 to 1963 at Avenue G and Ninth Street. It was refaced when it was converted to the Iowa State Bank in the late 1960s. The post office is now at 1019 Avenue H. The Hayle Pharmacy at right (835 Avenue G) has been H. G. Haessig, Martin's Grocery, and more recently Kelly Cakes.

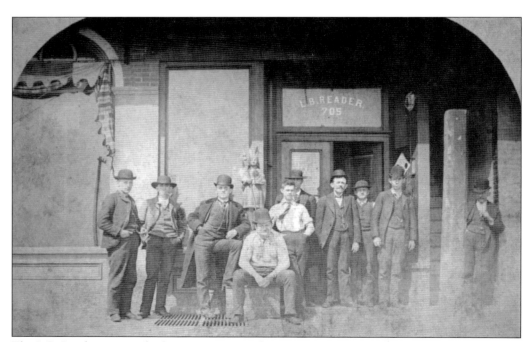

The L.B. Reader cigar and tobacco store opened in 1875 at 705 Front Street (Avenue H). Louis B. Reader came to Fort Madison in 1872 with his wife, Matilda. Reader manufactured two new cigars in 1877, the Royal Seal and Little Lottie (named after his daughter). After Reader died in 1900, prior apprentice William H. Hutton purchased the business and ran it until 1957.

George Robers owned a saddle and harness-making shop in the 600 block of Avenue G. The shop burned down in a fire in 1874 that destroyed most of the block. He rebuilt the saddlery the following year. Shown here is a metal button that could be found on his wares. Robers served on a committee that was instrumental in getting the bridge built here in Fort Madison. (Courtesy of Kathy Burkhardt.)

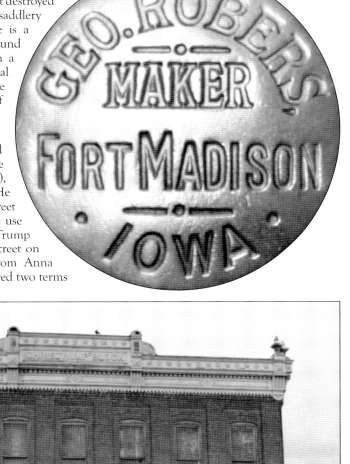

Christian Trump owned several buildings in proximity to this one at 1201 Front Street (Avenue H), which was a feed and sale barn. He owned a livery at 1207 Front Street and charged $5 for an evening's use of a team of horses. In addition, Trump owned the building across the street on Locust, which he purchased from Anna Jacobsmeier in 1892. Trump served two terms as sheriff.

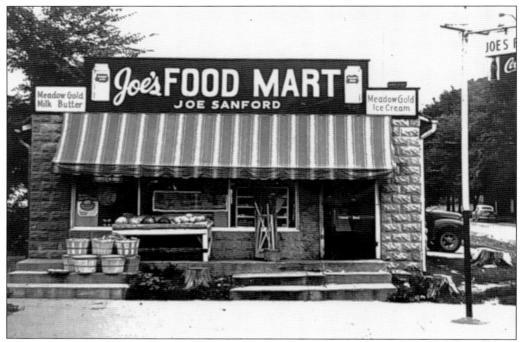

Built in 1924, this building housed Albert Hotop's Handy Market Meats. Located at 1501 Avenue D, the slaughtering took place in the back. Customers would pay attention to what was being slaughtered so they could buy the freshest cuts of meat. The meat market operated for about three years. It was Joe's Food Mart from 1938 until 1958. It is currently a residence.

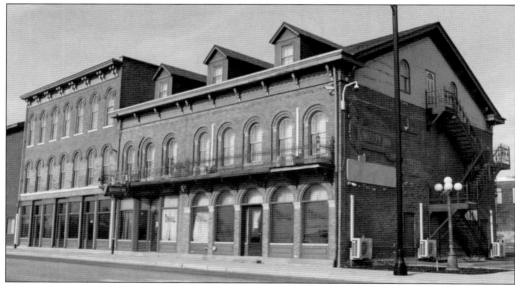

At 707 Avenue H, the Kingsley Inn has been restored to mid-1800s decor. Originally home to the Windmayer Whiskey & Vinegar Distillery in 1861, it has housed several businesses over the years. The Troy Laundry moved there in 1910 and operated until 1981. Named after Alpha Kingsley, the Kingsley Inn has 19 rooms, and is reputed to be haunted. (Courtesy of Kathy Burkhardt.)

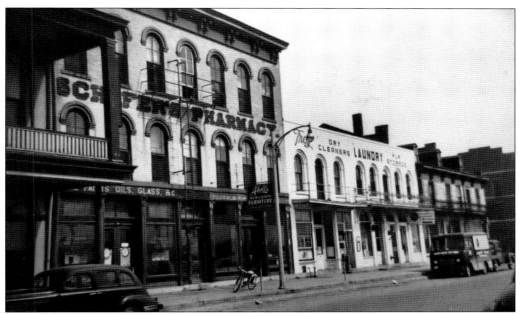

Established in 1909, Troy Laundry changed ownership several times before Leo and Henry Watznauer took over in 1920. Named for the Troy equipment used, it was located at 707–709 Avenue H. At 715 was Schafer Pharmacy, not to be confused with Sheaffer Pen Company. The laundry offered fur storage and dry cleaning, as well as pick-up and delivery services. In the back were several Troy pressing machines, one for each portion of the shirt, including the collar, cuffs, sleeves, and body. In the 1930s, Troy advertised free patching of overalls for Santa Fe workers, hoping to entice more business. The 1950s advertising slogans included "We wash everything but the baby!" and "Let our sanitary bubbles wash away your troubles!" This building is currently the Kingsley Inn.

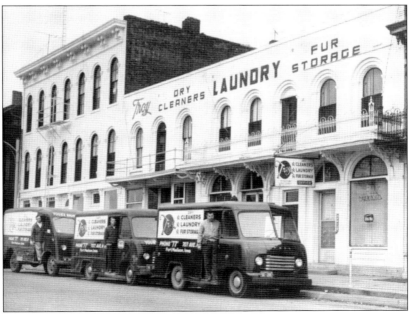

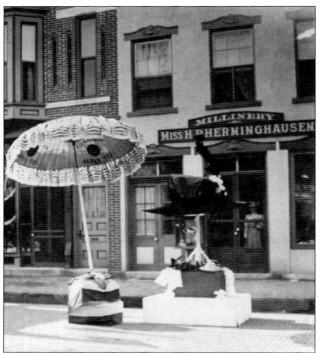

The Victoria Gallery Tea Room, located at 718 Avenue G, was once the site of a popular millinery owned by local businesswoman Hattie Herminghausen. She sold hats out of this downtown shop. More recently, the property is owned by another businesswoman who has turned it into a successful art gallery and tea establishment. (Courtesy of Kathy Burkhardt.)

In this 1959 photograph, logs on gondola cars via the spur line are headed into Crandon Paper Mill (Eighteenth Street and Avenue O). Reportedly at 4:00 every day, one could smell the distinctive odor of the mill, which drifted as far away as West Point, Iowa, and Dallas City, Illinois. Opened in 1882 as the Fort Madison Paper Mill, it closed in 2005 and later became 4M Packaging Company.

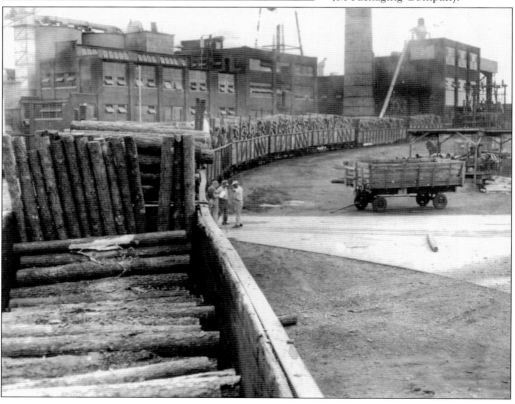

Five

SCHOOLS

Fort Madison has a long history of education, both public and private. Rebecca Palmer, the first woman teacher in Iowa, started a school in Fort Madison in 1834. The Presbyterian Church was host to high school classes in 1843. In 1864, the Fort Madison Academy was opened and ran until 1875.

Pine School (Fifth and Pine Streets) was known as the first schoolhouse in Fort Madison. Sallie R. Smith was selected as principal in 1881. It operated from 1859 until 1893 when Jackson School was constructed.

In 1866, a school for Black students opened. On Second Street, it started with 13 students. By 1876, they were transferred to public schools. The public high school held classes in the Baptist church on Third Street (Avenue F) and boasted an 1879 graduating class of three: Birdie Wilson, Emma Layton, and Sabert M. Casey. In the 1880s, classes were held in several locations, including churches and storerooms. By 1889, two brick schools—Santa Fe Avenue School (Richardson) and Union Avenue School (Jefferson)—were constructed in the west end for $11,831. In 1916, Conception Morales Brown opened a school to teach English to Spanish-speaking residents. Nola Davis instructed Spanish-speaking children starting in 1924. The classroom, called "the Mexican Room," was located at Richardson School. Interestingly, this classroom was purchased by Alejandra Lozano in 1955 and moved to 403 Thirty-Fourth Street for use as a home.

Fr. John Alleman was the first teacher in the Catholic school system in 1840. St. Mary's opened a separate school, later replacing it in 1876. A west-end school was opened on Santa Fe Avenue in 1892. Sacred Heart Parish School opened on Twenty-Third Street and Avenue J in 1958. The elementary grades were divided in 1985 into St. Joseph (Aquinas East) and Sacred Heart (Aquinas West). In 2005, Aquinas merged with Marquette (West Point) to become Holy Trinity Catholic Schools.

The Fort Madison Business College, founded by Nelson Johnson in 1879, taught skills such as typing and how to use an early Dictaphone. The college stayed open until 1948.

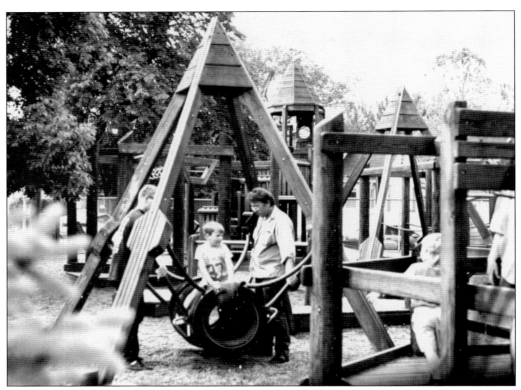

The first Lincoln School was built in 1886 at Fifth and Market Streets (Avenue D and Eighth Street) and had six rooms and a bell tower. Originally used as a high school, it cost $15,000 to build. In 1896, the principal was John McCulloch and five teachers were employed there. It was torn down around 1934. The new Lincoln School was built in 1932 at Avenue E and Fourteenth Street. Lincoln School most recently held classes for kindergarten through third grade students. The school was "retired" in 2024, and students were transferred to the new addition at the middle school. Pictured on the old "Eagle's Nest" playground is Rambo Burkhardt with his father, Mike Burkhardt. (Courtesy of Kathy Burkhardt.)

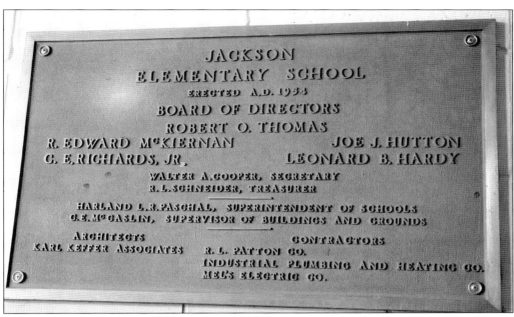

Jackson School opened in 1893 when it replaced Pine School. It was built as a First Ward School. In 1895, Miss Maggie Frailey was the principal and three teachers were employed there. Jackson served as an elementary building until it closed in 1975. Students attended class in temporary wooden rooms parked in the school yard at Lincoln School. Before it was sold, Jackson School was home to the Great River Area Education Agency. Located at 305 Avenue F, the building was eventually repurposed into Jackson Square Apartments (pictured below). The bell tower has been removed and the roofline changed. (Courtesy of Kathy Burkhardt.)

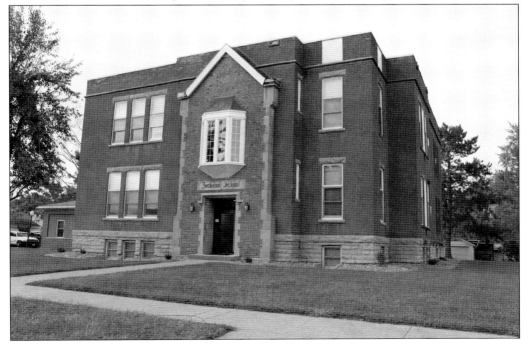

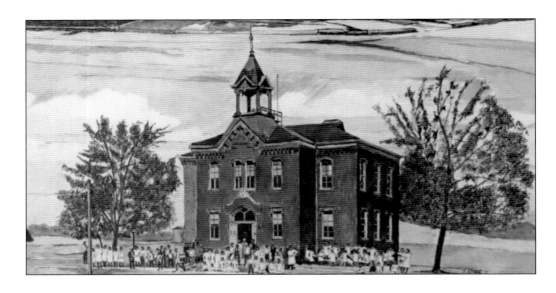

In 1896, C.R. Lamb was principal of the original Jefferson School (above) and three teachers were employed there. At that time, it was known as the Union Avenue School. The new Jefferson School (below) was built in 1914 at 2301 Avenue G. It was built using the same basic floor plan as Richardson Elementary School to save money on the architectural plans. An addition put on in 1950 added six new classrooms and a gymnasium. Students were known to have marble tournaments on the front lawn. Jefferson School was closed in 2003 and demolished around 2008. (Drawing courtesy of Jim Knapp.)

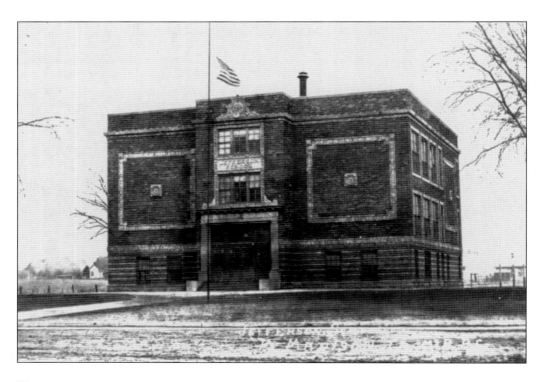

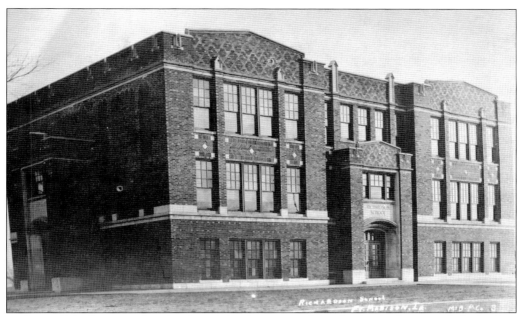

Built in 1889, the original Richardson School was named for the family that owned the land. It was razed in 1918 and replaced with this building, which has undergone several changes. It was never outfitted with central air conditioning, and students had to endure temperatures well over 100 degrees in August. Richardson was "retired" in 2024, and students were transferred to the new addition at the middle school.

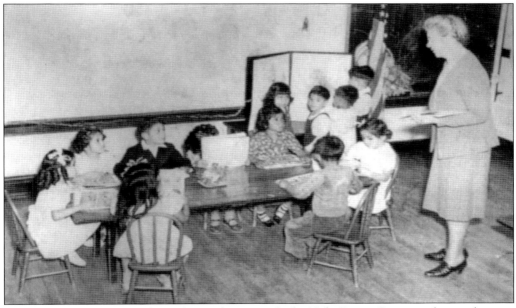

These students are engaged in a lesson being taught by Nola Davis. Davis taught in what was known as the "Mexican Room" at Richardson School starting in 1924. Seated around the table from the left are Theresa ?, Frances Munoz, Felix Sanchez, Mary Vasquez, Frances Munoz, Sallie ?, Bobby Guzman, and Sally Mendez. (Courtesy of Angela Salazar.)

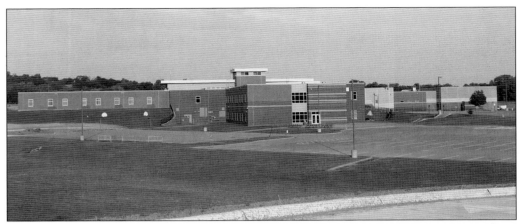

The Fort Madison Middle School is located at 502 Forty-Eighth Street and was open to students in 2012. It was built to resemble a barge with water sluicing off the windows. It housed grades four through eight until the fall of 2024, when a new wing was added. The building is now used for pre-kindergarten through sixth grade. (Courtesy of Kathy Burkhardt.)

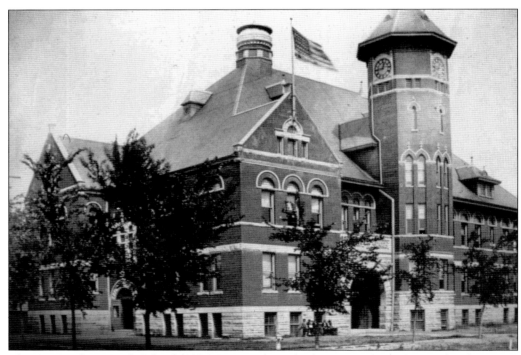

The Fort Madison High School (1325 Avenue F) was built in 1894 for $35,000. The three-story brick building had a six-story tower. Jeweler Fail Scovil installed a Seth Thomas clock in the tower. The bell tolled the hours, but would occasionally get stuck and toll all night. It became the Fort Madison Junior High in 1923 and was demolished in 1959.

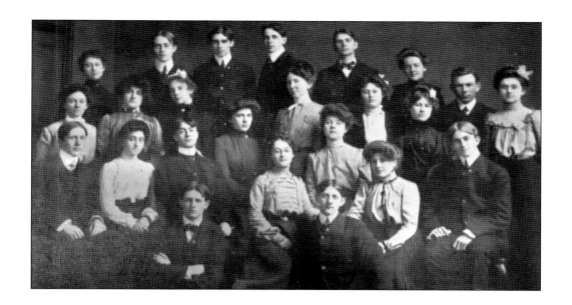

Back in the day, students were required to attend school until eighth grade. Those who wanted to go to high school had to stay in town and board. Shown above is the Fort Madison High School class of 1902. From left to right are (first row) Roy Berstler and Rolla Cowles; (second row) Casey Hamilton, Edith Benbow, Edward Roberts, May Finch, Elizabeth Tower, Daisy Atlee, and Robert Scovel; (third row) Ruth Binder, Helen Reifnach, and Jessie Hopkirk; (fourth row) Vida Williams, John Scovel, Dow Wagoner, Dan Davis, Rudolph Schlapp, and Alma Fruehling. By contrast, the class of 1938 (below) is much larger. Students from outlying areas were bussed in by this time, creating larger class sizes. A population boom in the 1970s caused classes to be over 200 students.

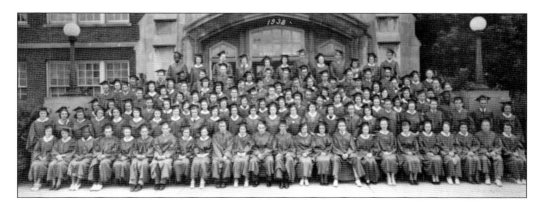

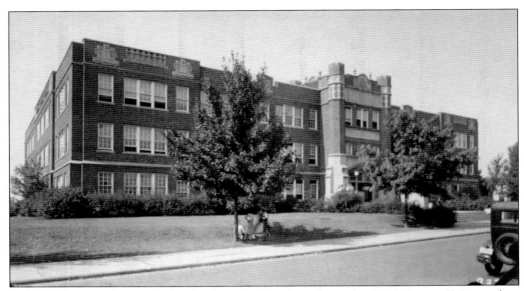

In 1923, the second senior high school was built and was located at 1812 Avenue F. It was then used as the junior high from 1958 to 2012. When a new middle school was built in 2012, this building was sold and eventually repurposed into 38 state-of-the-art solar-powered apartments in 2016. Each apartment retains a bit of brick wall and a chalkboard feature.

The current Fort Madison Senior High School (2001 Avenue B) has had several additions over the years. Originally built in 1959, the school cost over one million dollars. The most recent addition to the building completed in the fall of 2024 included classrooms for seventh- and eighth-grade students, a new music wing, and a new gym. (Courtesy of Kathy Burkhardt.)

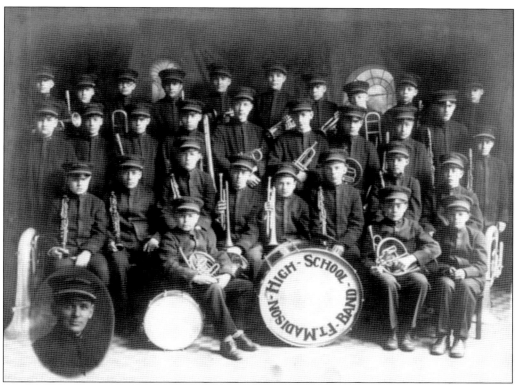

Fort Madison has a strong history of all types of bands. The high school music program currently includes a concert band, marching band, jazz band, and show band. The photograph above features a Fort Madison School Band around 1907. Notice that the band is all boys, and the director is in the lower-left corner. Taken by John Amborn, the photograph below shows some of the 1966 high school band getting ready to perform at the ground-breaking ceremony of the Fruehauf Trailer Company. From left to right are Diane Strickler (cymbals), Sherry Dunsworth (bass drum), Steven Sears (snare), Wayne Lauffer (clarinet), John Collier (trumpet), and Roger Hugg (trumpet). On the far right is Wilbur Dalrymple. Director Larry Miller has his back to the camera.

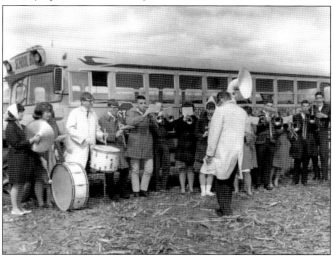

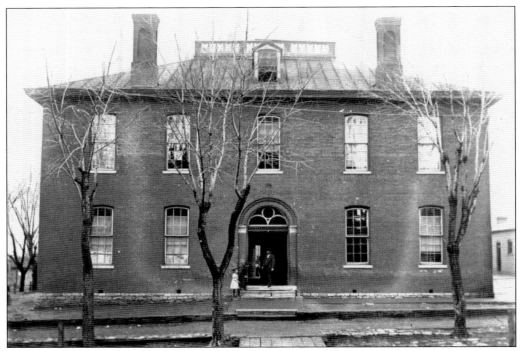

St. Mary's School was opened in 1865 by the St. Mary's parish to accommodate the growing number of students. Shown here in 1898, it was located at the corner of Fourth Street and Vine Street (Avenue E and Eleventh Street). In 1899, the building was replaced with a larger school at the same location, pictured on the facing page.

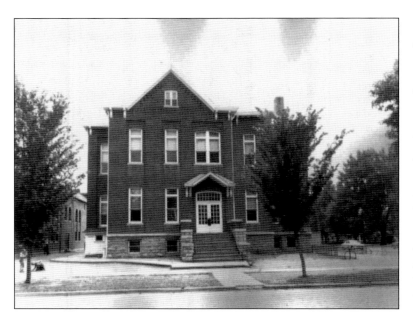

The Sacred Heart Parochial School, 2216 Avenue I, was directly across from Sacred Heart Church. "1893" is engraved above the door, the year it was built. At one point, there were about sixty students in one class with one nun teaching. A bell tower was taken off when the back of the school was added to. The school was closed in 1977 and demolished in 1990.

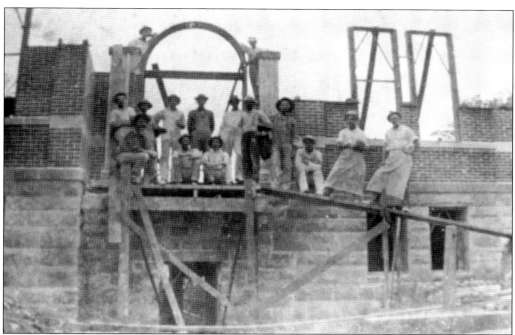

Workers pose in front of Saint Mary's School at the corner of Fourth and Vine (1103 Avenue E) during construction in 1899. Students were taught in German because a large number of them spoke German at home. This building became known as the Central Catholic High School in 1925 and served students from both St. Mary's and Sacred Heart parishes. Students attended high school there until 1959 when it became an elementary building. It consolidated with St. Joseph's to become Aquinas. The building became vacant in 1977. It was destroyed by fire on August 3, 1979, and was torn down shortly after. The photograph to the right shows the cleanup after the fire.

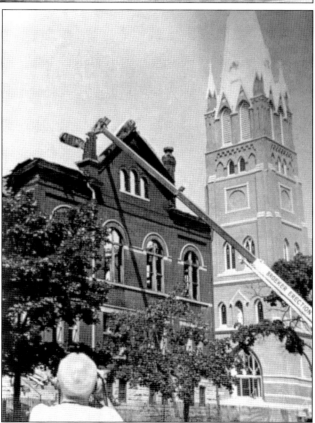

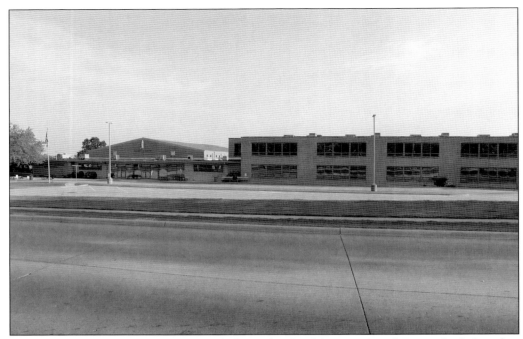

Construction began on the Aquinas Catholic High School (Avenue A and Twenty-Sixth Street) in 1957. The school was built to house over 400 students. Students were charged $80 each for school expenses for the school year. It is now the Holy Trinity Catholic Junior/Senior High School. (Courtesy of Kathy Burkhardt.)

St. Joseph's School was constructed in 1926. It was part of St. Joseph's Church Complex, which included the church, school, rectory, chapel, and convent. The complex, located in the 500 block of Avenue F, is in the National Register of Historic Places. The school has been converted into offices and apartments. (Courtesy of Kathy Burkhardt.)

Six

CHURCHES AND CEMETERIES

The first church services in Fort Madison were held by Presbyterians in log cabins in 1838. They later met in the new courthouse, until 1846 when a small brick church was built. The Methodists organized in 1839 and built their first church three years later. They were served by a minister traveling a circuit. Several members of this congregation were Black, including the Holland family who had come to Fort Madison directly out of slavery, and joined the church in 1865. Another notable member of the early church was "Aunt" Sally Alexander, who called herself a "Shoutin' Methodist."

The first Catholic community in Fort Madison was St. Joseph's Parish. In 1840, Fr. John Alleman answered the call for a German-speaking priest to serve the German people in the area. In 1865, St. Mary's was the second Catholic church to be built, followed by the Sacred Heart Parish, which was built in 1893. St. Joseph's and St. Mary's combined in 1996, followed by the merger of all the parishes in 2008, becoming the Holy Family Parish.

There have been several Baptist churches, including First Baptist, Second Baptist, Third Baptist, Grace Baptist, Madison Baptist, and Village Baptist. Known as the Mexican Baptist Church, Village Baptist members met in homes in the Mexican Village until 1937, when Village Community Church was built at 3433 Avenue O.

Fort Madison has its share of cemeteries as well, including Box Grave, Elmwood Cemetery, Fort Madison City Cemetery, Gethsemane Cemetery, Hillcrest Memorial Park, Hoffmeister Cemetery, Hyde Grove Family Cemetery, Oakland Cemetery, Old Fort Madison Cemetery (located at the Battlefield), Sacred Heart Cemetery, and Slack Cemetery. Interestingly, the exact location of the Slack Cemetery is unknown, last having been seen in the 1930s around the old Currier place, at the head of Burlington Hill. Several of these are considered "Pioneer Cemeteries," those that have had 12 or fewer burials in the last 50 years.

This chapter does not reflect all of the churches that Fort Madison has enjoyed over the years; it would be impossible to represent them all.

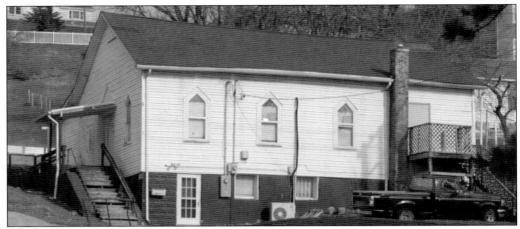

Organized by Reverend Chambers and Reverend Cleanan in 1870, the Second Baptist Church is the oldest of the Black churches in the city. It was located at 514 Market Street (310 Eighth Street). A church was built in 1880 followed by another in 1940 (pictured here). The new church at 3121 Avenue N was completed in 1986. (Courtesy of Kathy Burkhardt.)

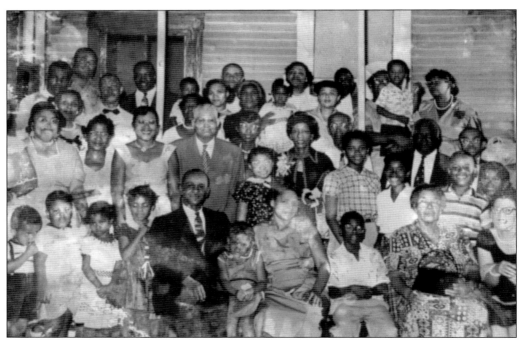

This photograph depicts the congregation of the Second Baptist Church on the porch of the parsonage in 1959. Unfortunately, this is one of the only remaining photographs after the area was flooded. The pastor, Rev. C.S. Jones, is seated in the first row with a dark jacket. Several families are represented, such as the Bates, Clarks, Rudds, and Windsors.

Elmwood Cemetery is located in the 2100 block between Avenues L and M. Elmwood's first known burial which still has an existing marker was that of Jane S. Cowles in 1841. Adelaide Pollard, author of the hymn "Have Thine Own Way, Lord" is also interred here. In addition, 30 members of the Atlee family and 18 members of the Benbow family are buried here. (Courtesy of Kathy Burkhardt.)

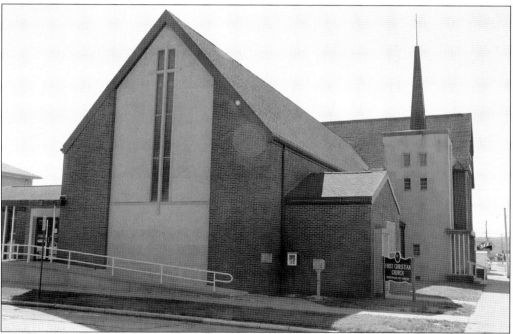

Rev. T.A. West was the first minister of First Christian Church. The congregation met in homes and the courthouse before a wooden tabernacle was erected in 1897 for $800 (Avenue F and Tenth Street). A large brick church was built in 1907 and then was razed and replaced in 1957 with the building shown here at the same location. (Courtesy of Kathy Burkhardt.)

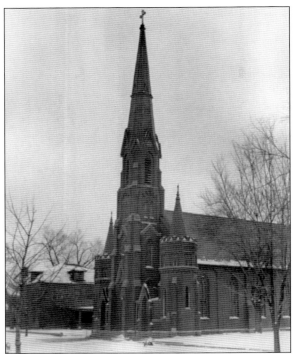

St. Joseph's Catholic Church was founded in 1840. The first building was at 516 Third Street, measured 16 by 18 feet, and was made of some of the first bricks to be manufactured in Fort Madison. The second church building was completed in 1847, and the third was completed in 1886. Built of brick in the Gothic Revival style it is still standing today.

The Santa Fe United Methodist Church was founded in 1889. A new building was erected at 2811 Santa Fe Avenue (pictured) in 1913. The New Hope United Methodist Church, a small Black church of 23 members, merged with Santa Fe in 1969. A new sanctuary was built at 2815 Avenue L to hold the 800-member congregation. Joy Baptist Church purchased the building in 2012.

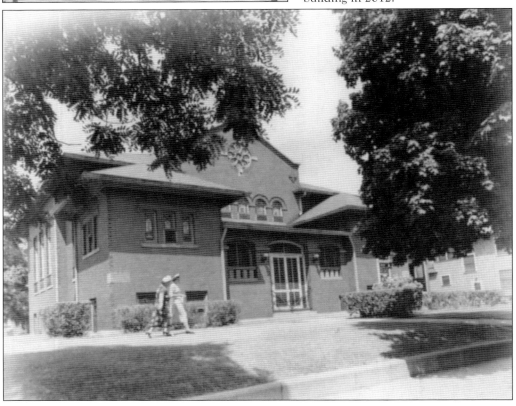

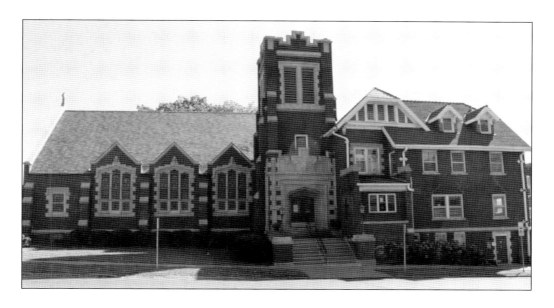

The first building for the Methodist church in Fort Madison was a one-room brick built between Avenues E and F on Eighth Street in 1842. Part of a circuit, this church received its own minister, Rev. D.B. Nichols, in 1844. The second building was dedicated in 1888 at 701 Avenue E, (currently a residence). Due to growing membership, a third building was erected at 902 Ave E and dedicated in 1923 (above). The Santa Fe United Methodist and First United Methodist Churches merged in 2011 and worship here. The church has a large history of celebrating with music and has hosted a Community Hymn Sing for many years. The church also has a choir, bell choir, and children's Christmas pageant (pictured below in 1993). (Above, courtesy Kathy Burkhardt.)

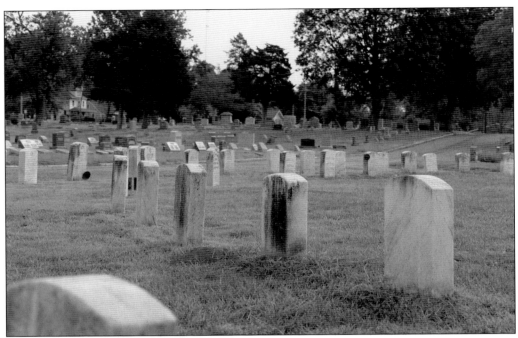

Soldier's Circle is located in the heart of Oakland Cemetery. Services are held on Memorial Day with hundreds of flags flying. Dedicated in 1931, the circle can be the final resting place for any Lee County military personnel with at least 90 days of service and an honorable discharge. Oakland holds several members of the 16th Illinois Cavalry who survived Andersonville Prison. (Courtesy of Kathy Burkhardt.)

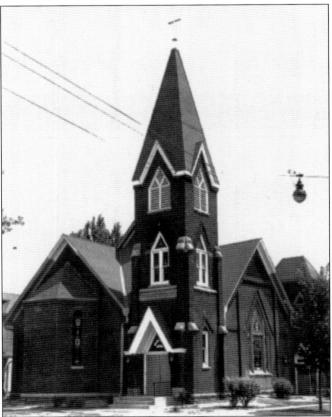

St. Paul's (English) Lutheran Church congregation originally met in the old German Lutheran Church (Avenue F and Tenth Street). The church was founded by Rev. John F. Seibert in 1892. This building at the southeast corner of Hanover and Des Moines Streets (1934 Avenue I) was completed in 1897. A pastorate, parish hall, and recreation building were added in the early 1920s.

Located at 2217 Avenue I, Sacred Heart Catholic Church is constructed of No. 1 Blue Bedford and Indiana stone and sports a French tile roof. The statue at the peak, which is nine feet high and weighs 7,000 pounds, was hauled up by a team of horses and a pulley system. Rev. Peter Hoffman organized the church in 1893, and it has been in continuous service ever since.

Sacred Heart Cemetery, often called "Rashid Cemetery," was transferred to the city in 1974 and is located west of town on Forty-Eighth Street. Jacob and Saida Rashid, pioneers of the vicinity, are interred here, as well as over 40 members of the Rashid family. They had 18 children, many descendants of whom still reside in the Fort Madison area. (Courtesy of Kathy Burkhardt.)

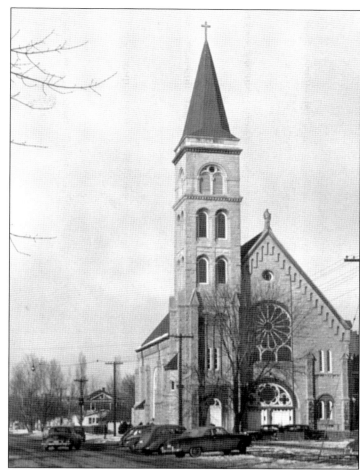

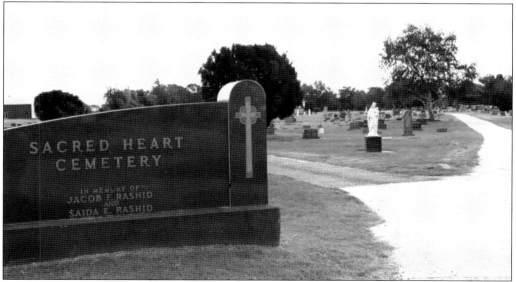

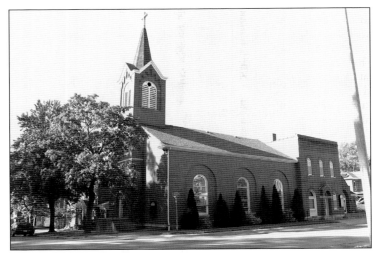

St. John United Church of Christ is located at Avenue E and Tenth Street. Originally, it was St. John's Evangelical and Reformed Church. The first church was built in 1850 at 505 Tenth Street, the site of the current parsonage. The corner lot was purchased in 1864 for $160, and a new church was built. In 1948, the building was enlarged. (Courtesy of Kathy Burkhardt.)

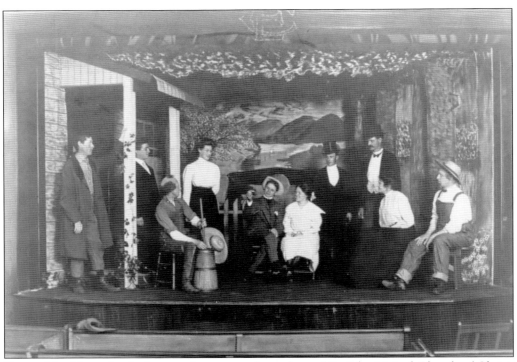

Pictured in this undated photograph are several members of St. John United Church of Christ. The folks posed here were in the cast of "Uncle Rube." From left to right are Julius Almendinger, Will Lesch, Ralph Voigt, Gertrude Podyne, Ed Almendinger, Amelia Haessig, George Schaile, Al Passer, Laura Miller, and Henry Smith. (Courtesy of St. John United Church of Christ.)

For $40,000, St. Mary's Catholic Church was built at the corner of Vine and Fourth Streets (Eleventh and Avenue E) and was dedicated in 1871. The 226-foot tower was the tallest in Iowa at the time. A windstorm in 1876 toppled the steeple into the sanctuary. It was rebuilt in 1890. St. Mary's joined the National Register of Historic Places in 1981. (Courtesy of Kathy Burkhardt.)

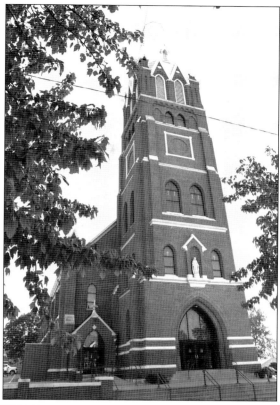

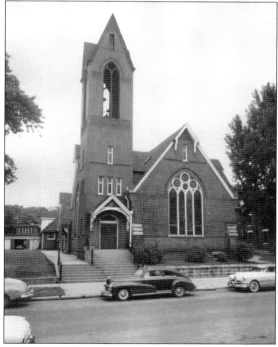

Union Presbyterian Church was organized in 1838. The original building on Third Street between Pine and Market was completed in 1844 and used for 40 years. The church divided into the New School and Old School branches. In 1859, the two branches were joined into the Union Presbyterian Church. The current church building, pictured here, is at 719 Avenue F and was dedicated in 1885.

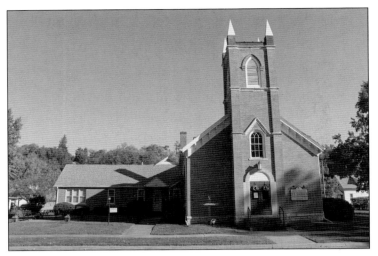

St. Luke's Episcopal Church (605 Avenue E), was originally known as Hope Episcopal Church. It is known for having a red front door to distinguish it from other churches in the area. Built in 1857 in the Gothic Revival style, it is Iowa's oldest Episcopal church. Rachel Albright donated her last replica flag to the church, where it can be seen today. (Courtesy of Kathy Burkhardt.)

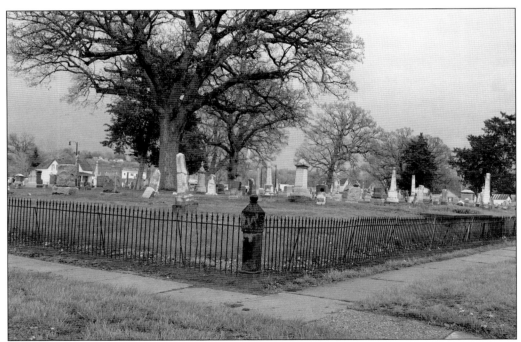

City Cemetery (1402 Avenue H) is the oldest and smallest of the cemeteries in Fort Madison. According to folklore, Native Americans were buried here and hence this location was chosen for a cemetery. The first known burial that is still marked is that of Gen. John Holly Knapp. Three granddaughters of Betsy Ross are also buried here. (Courtesy of Kathy Burkhardt.)

Seven
Notable Homes

Fort Madison was platted in 1837 and developed after the city was founded in 1838. In the National Register of Historic Places, the Park-to-Park Residential Historic District is roughly three blocks wide and seven blocks long, extending from Old Settlers Park to Central Park. Brick single-family homes intermingle with multi-family houses, churches, and commercial buildings. Most of the buildings are constructed of brick, due to the large number of bricks produced in the area. Several architectural styles can be found, including Gothic Revival, Italianate, Queen Anne, and Romanesque. Many of these homes belonged to prominent businessmen, and the district was a desirable place to live and raise a family.

While strolling through the district, the homes of many prominent people from back in the day can be found. Along Avenue E are homes that once belonged to Col. Joseph Morrison, George Rump, Joseph M. Beck, and Caroline Cattermole. Along Avenue F are houses once owned by Dennis Morrison, Bernard B. Hesse, and Conrad J. Amborn.

One notable home not in the district is a 16,000-square-foot Renaissance Revival and Tudor Revival mansion (11 Highpoint). Built by Walter A. Sheaffer (inventor of the lever-filled fountain pen) it was completed in 1930. James Ringling of the Ringling Brothers Circus purchased it in 1973. Local lore says that Ringling kept several large circus cats in the home, giving them free rein. Another home not in the district is the George Schlapp House (639 Avenue C). Built in the Italianate style in the early 1870s, this home overlooks the Mississippi River. Schlapp built a brewery on Front Street and was involved in banking, the narrow-gauge railroad, and stock brokering.

Hattie Herminghausen was a female entrepreneur, which was unusual for the day. She built this three-story Second Empire home at 517 Front Street in 1898, where she lived with her mother, sister, and three brothers. She purchased the building next door with profits from her successful millinery business in downtown Fort Madison. Interestingly, the house, which is still standing, is attached to the commercial building.

The Atlee home (903 Avenue E) was built by William Augustus Atlee in 1895 and occupied by nephew William Henry Atlee's family. In summer, people would gather in Central Park to listen to orchestral music being played in the ballroom. The home, complete with a tower, was known as the "Mansion" and is commonly referred to by locals as the "Castle House."

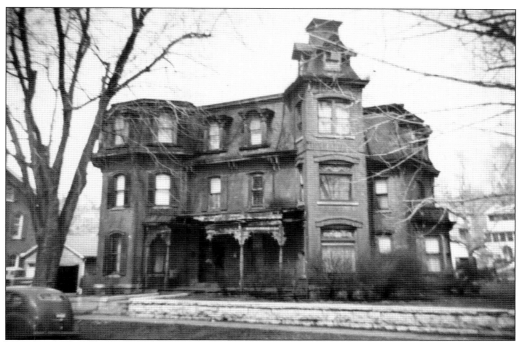

This large brick Second Empire home was built by Col. Joseph Morrison (of Morrison Plow Works) in the 1870s as a birthday present for his wife after he returned from the Civil War. The left wing was added in 1886, and the right wing with the tower was added in 1891. The family had 10 children, and the home at 415 Avenue E had 15 rooms. The third floor contained a ballroom and a billiards room. Several changes have been made to the home, including the removal of the third floor and the front porch. The structure is now an apartment complex (below). (Below, courtesy of Kathy Burkhardt.)

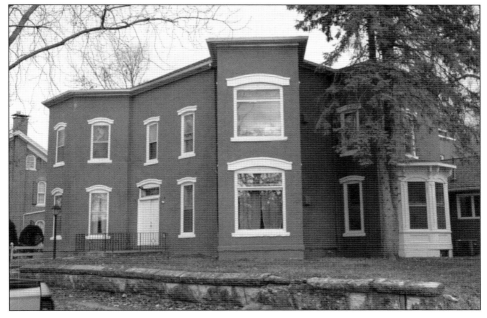

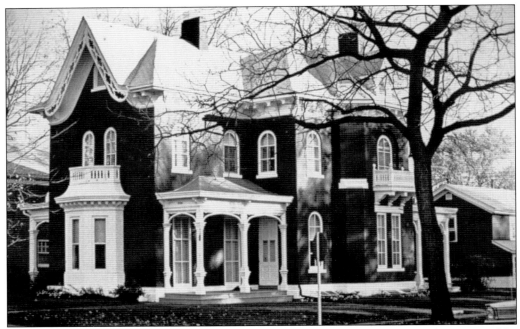

Built in 1859, this Gothic Revival/Italianate located at 314 Pine (630 Avenue E) was owned by judge Joseph M. Beck. After he moved to Fort Madison in 1850, Beck was elected mayor and prosecuting attorney. This two-story brick is in the National Register of Historic Places and is painted in the original red color.

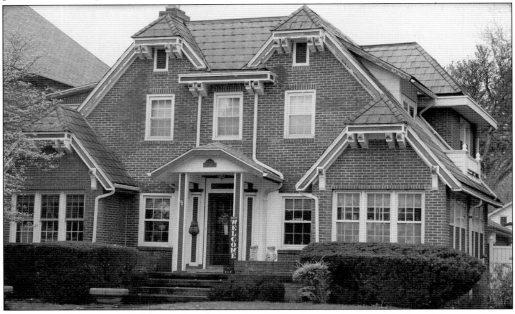

This unique home at 717 Avenue E was erected in 1933 when Dr. Remers hired a Chicago architect to draw up the plans. The house is full of symmetry, with many of the doors and windows lining up so one can see straight through from one end of the home to the other. Remers planted a tulip tree in the backyard that still stands. (Courtesy of Kathy Burkhardt.)

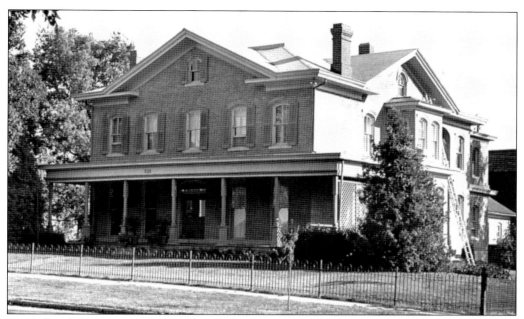

Located at 532 Avenue F, this brick Italianate home was built around 1879. Owner Dennis Morrison was a partner in the Morrison Plow Works (located where W.A. Sheaffer Pen Company is currently). Morrison and his brother, Joseph, had been in the army in the Civil War and saved up their pay to reopen the company as S.D. Morrison and Sons.

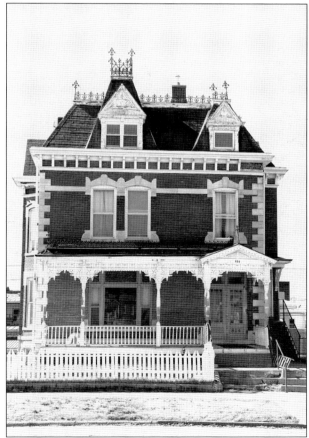

This three-story Second Empire home was built by Charles Doerr at 814 Third Street (Avenue F). Doerr held several positions in the area, including lawyer, postmaster, city clerk, and stonemason. He was instrumental in bringing the railroad to town in the 1880s. While the mansard roof still has its ornamental iron cresting, the home has been turned into a three-plex.

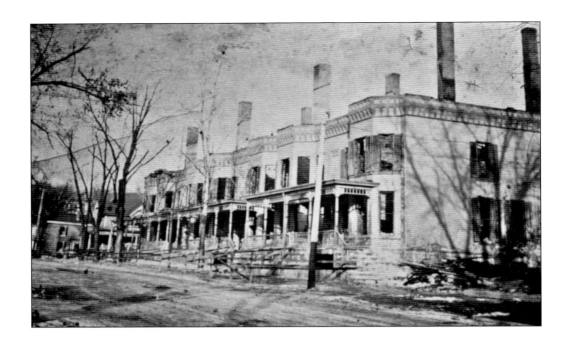

In December 1916, a fire raged through the wooden third floor of the Atlee Flats. Each family had two floors in the brick portion and the stick-built third floor housed service personnel. The fire started on the roof of the third floor. The basement held 13 tons of coal, which contributed to the fire. Over 40 residents escaped the blaze and watched alongside the firemen as huge icicles formed on the brick walls. This dwelling, also known as the Atlee Apartments, is located at 502–514 Eighth Street and dates to 1887. Today, this building has been renovated (below), but the third floor was never replaced. (Below, courtesy of Kathy Burkhardt.)

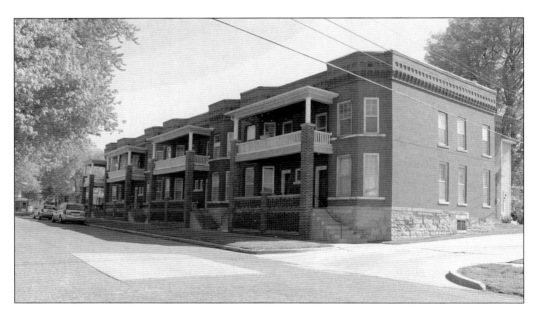

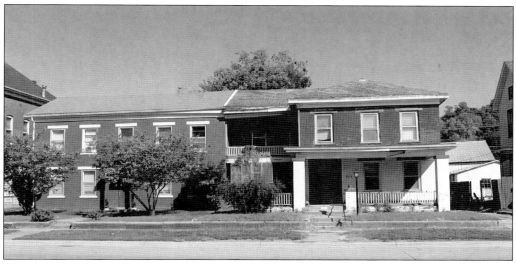

This duplex (821 and 823 Avenue E) was built by Harriet Knapp (wife of Gen. John Holly Knapp) for her sons John and Jonas. She lived in Fort Madison until moving to Wisconsin in 1863. The home on the right was sold, but the one on the left was deeded to Knapp's daughter Amelda Douglass in 1848. (Courtesy of Kathy Burkhardt.)

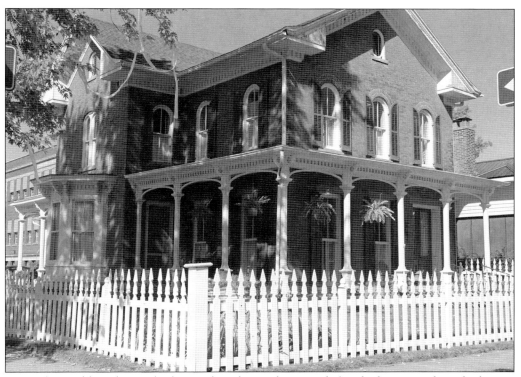

Across from Old Settlers Park, this Anglo-Italianate home with four bedrooms and one bathroom was built in 1871 by local architects Marr & Crepps. Located at 521 Fifth Street, it boasts over 2,500 square feet. The bricks were installed by Aaron Orm and Sons. This home still has the original shutters, porches, and interior wood trim. (Courtesy of Kathy Burkhardt.)

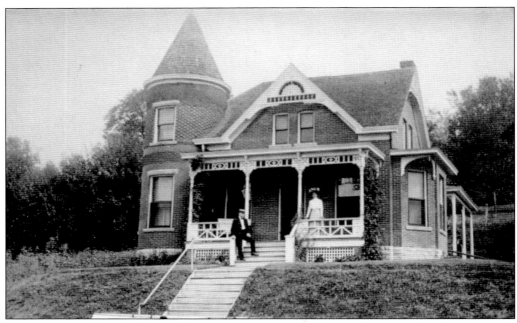

This unusual Queen Anne home at 1009 Avenue C was built around 1896 by owner Robert Fuchs who was a mason. He later sold it to his sister, Mary Sands. Note the removal of the gingerbread trim, corbels, gable decoration, porch spindles, and various other pieces of trim. The porch has been redone with a simpler railing, and new windows have been added to the house. Notice how the original trim had been painted plain, with no embellishment. The circular tower still remains, however, and the overall look of the house remains much the same. (Below, courtesy of Kathy Burkhardt.)

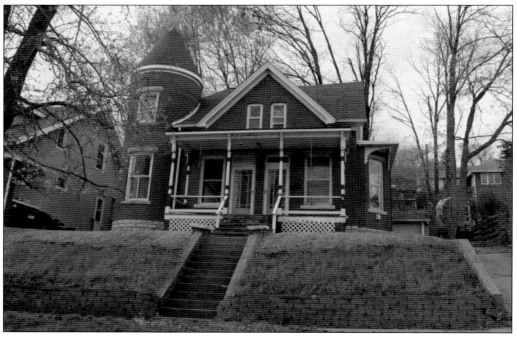

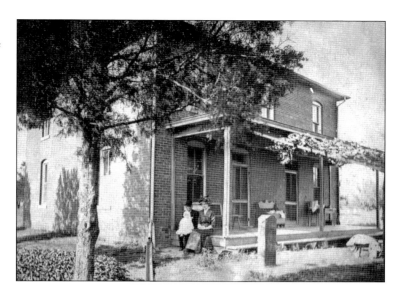

In front of this two-story brick (330 Avenue D) and dressed in their Sunday finest are George and Amanda Beckert, holding baby Albert. The home had been owned by George's parents, Joseph and Marie Beckert. George became a button cutter at the Fort Madison Button Company in the 1920s. He had an eighth-grade education, which was very common at the time.

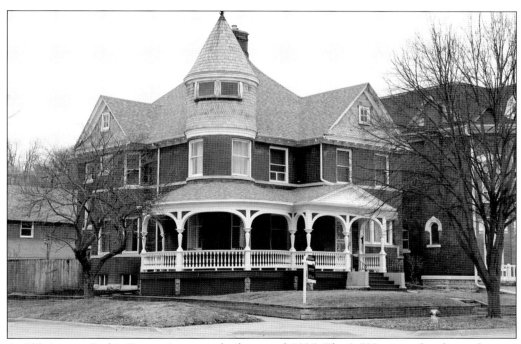

At 833 Avenue E, this Queen Anne was built around 1895. The 3,500-square-foot home features four bedrooms and three bathrooms. Caroline Cattermole purchased this property after the death of her husband, Arthur. The home has recently been restored to its original glory and retains much of its original woodwork. (Courtesy of Kathy Burkhardt.)

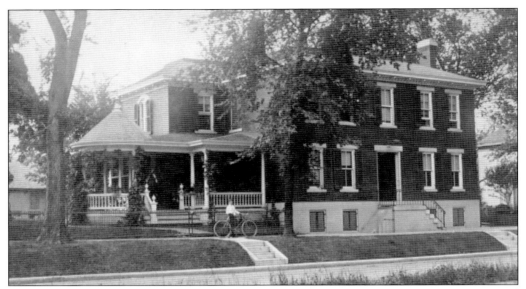

This home at 422 Avenue F was built by Dr. Edward Whinery (1812–1868), a local physician and druggist. The dwelling, built around 1860, is currently a bed-and-breakfast. With over 5,600 square feet, it has five bedrooms and four bathrooms. It features an unusual cupola on top. Whinery survived his four wives and is buried in City Cemetery.

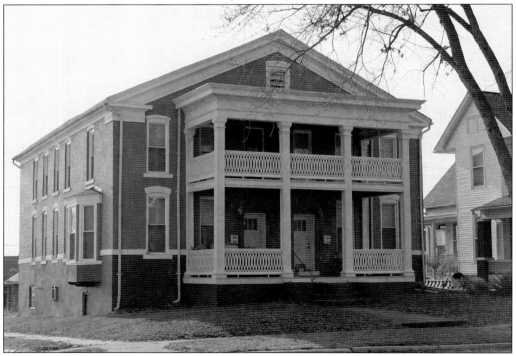

The first mention of this property lot was in 1844 in a patent deed. Built between 1865 and 1870, this two-story duplex at 602 Avenue F was purchased in 1881 by James Harrison Bacon for $1,671. Originally the Christian Church, a facade was later put on the outside, and the interior was split into halves and completely redone. (Courtesy of Kathy Burkhardt.)

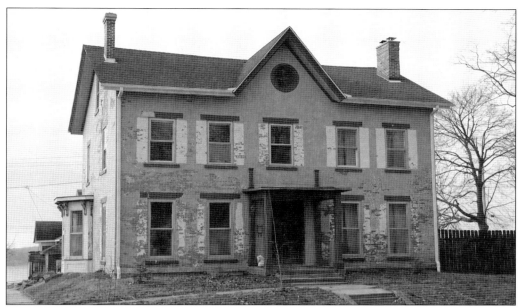

This residence at 402 Avenue F was built around 1855 by Isaiah Hale, owner of the first department store in Iowa, the New York Mercantile. Franciscan nuns converted the house into the Saint Elizabeth Hospital. For about a decade, it functioned with 15 patient beds and an operating room. It has been rumored that ghosts abide within this dwelling. (Courtesy of Kathy Burkhardt.)

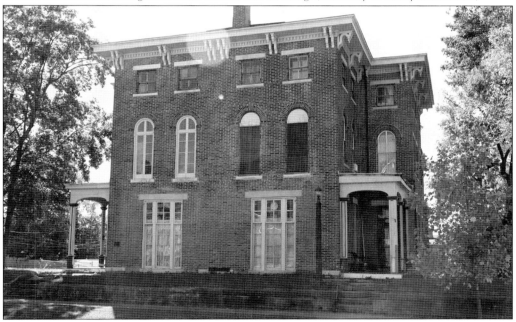

This three-story Italianate duplex at 716–718 Avenue F was commissioned by brothers Jacob and William Albright around 1857 for $14,000. The cost of the three-story Italianate home was $14,000. Jacob's wife, Rachel, was the granddaughter of Betsy Ross. The brothers owned the Albright Brothers Mercantile Store. Betsy Ross died in 1836, so she could not have visited this house. (Courtesy of Kathy Burkhardt.)

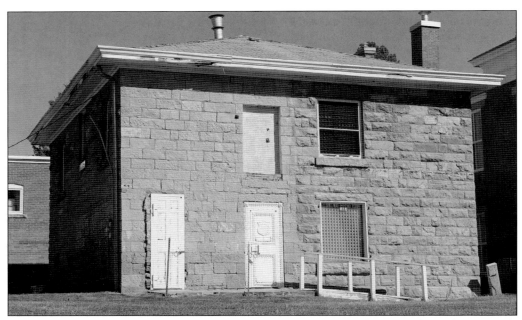

The old Lee County Jail (711 Avenue F) used to be attached to the sheriff's residence. Made of stone, it was built around 1865, while the brick house was built in 1869. What makes this structure unusual is that the previous jail, built around 1850, was absorbed into the back part of the home. It was in use until 1981. (Courtesy of Kathy Burkhardt.)

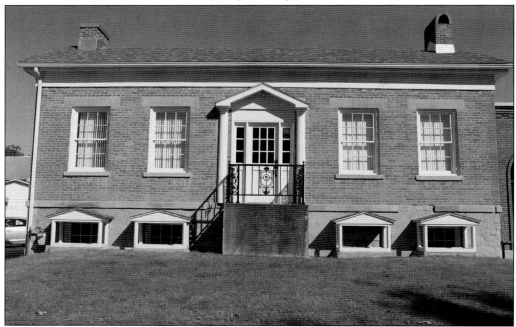

This home was owned and built in 1841 by Amos Ladd, a local mason who also worked on the Lee County Courthouse and the Iowa Territorial Prison. At 811 Avenue G, it was sold to the city of Fort Madison in 1965 and later incorporated into city hall. The home currently contains a meeting hall and offices. (Courtesy of Kathy Burkhardt.)

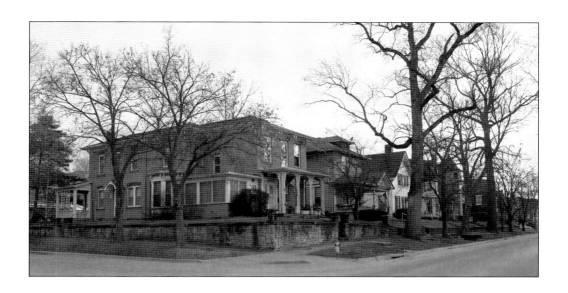

This row of homes in the 900 block of Avenue E has significant historical value. From left (above), 935 is a brick Anglo-Italianate home built in 1869. The property at 929 was built in 1895 and owned by Alfred and Arvilla Benbow. The one at 925 was built in 1878. The structure at 921 was built in 1905 and owned by James R. Benbow. Below, the Queen Anne at 919 was built in 1892 and owned by Frederick Kretsinger. The property at 915 was built in 1875 and owned by Conrad J. Amborn, and 909 was built in 1900 and owned by Albert Benbow. The structure at 903 was built by William Augustus Atlee. Interestingly, Harold and Louise Gray (daughter of Alfred and Arvilla) owned the home at 1007 Avenue E, keeping the row in the family for another generation. (Both, courtesy Kathy Burkhardt.)

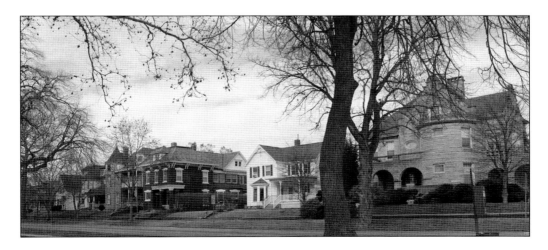

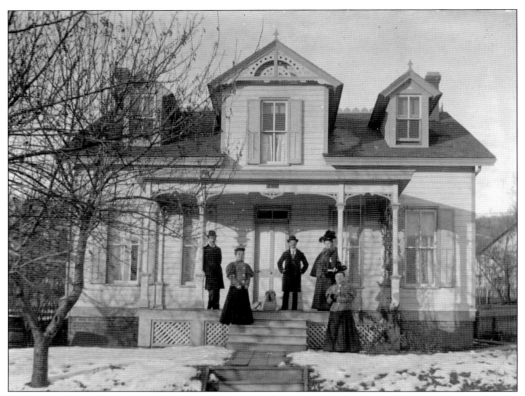

In front of this home at 1125 Third Street is the Cadwallader John "C.J." Williams family. Williams was born in 1869 and immigrated from Wales to the United States in 1885. He was a hobby photographer and lived here with his wife, Dina. He and his brother Robert opened up the Racket (834–838 Avenue G), a store that carried a variety of wares.

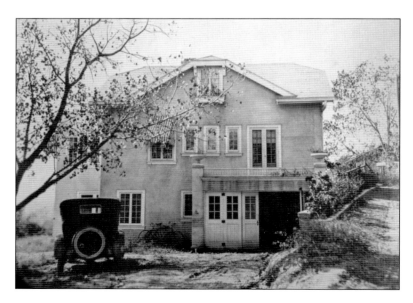

This abode at 1133 Avenue B (1102 Old Denmark Hill) was owned by Joseph Tower. The outside remains much the same. The garage has been renovated into a room in the house. The driveway has been moved to access the home from above. Tower owned the J A. Tower & Company dry goods store at 728–730 Second Street in the early 1900s.

Eight
Around Town

There are many places and activities citizens have entertained themselves with over the years, including parks, parades, and festivals. Occasionally, people need the help of public servants, such as the police department, fire department, and hospitals. Many changes in these institutions have occurred over the years, helping Fort Madison to keep up with the times. The first police force in Fort Madison was organized in 1864, with the hiring of eight officers earning a wage of $2 per night on duty. Leonard Carter was the first African American on the police force when he joined in 1955. Anne Smith was the first woman on the force when she joined in 1980. The volunteer fire department was organized in 1841 with an ordinance that required each building owner to provide buckets for the bucket brigade. Firefighters did not become salaried city employees until 1913. There have been several hospitals including the Atchison Topeka Santa Fe Hospital, Saint Elizabeth Hospital, Sacred Heart Hospital, and more recently the Southeast Iowa Regional Medical Center.

Fort Madison has many parks, including Ivanhoe, Old Settlers, Central, Shopton, Victory, Riverview, and Rodeo. Fort Madisonians love their parades and have celebrated many events with a parade of some sort. Usually, the parades head east on Avenue G. The Tri-State Rodeo parade starts as far west as Twenty-Third Street and ends with upward of 2,000 horses. Other notable parades include the homecoming parade, Charlie Korschgen Fourth of July Kiddie Parade, and the lighted Christmas parade.

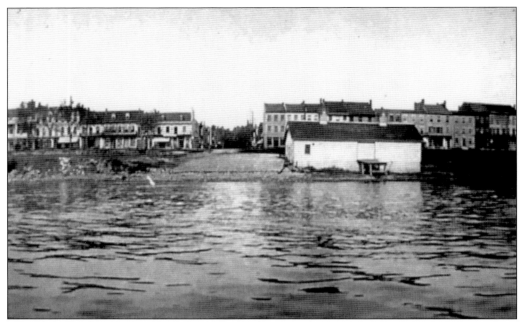

This photograph was taken from the river and shows Pine Street (Sixth Street). At one time, most of the streets on the east end of town came directly into the river like this one. People would load and unload onto riverboats and barges at the ends of the streets. The white building in front is the Diamond Jo Warehouse.

In this postcard of Riverview Park, one can see the depot. Two cannons were placed in 1916 as a memorial to all who have served in wars. Since it was set aside for public use in 1836, this land has undergone many transformations over the last 200 years, including tree planting, flowerbeds, and memorials. The Works Projects Administration expanded the park by 36 acres in 1936.

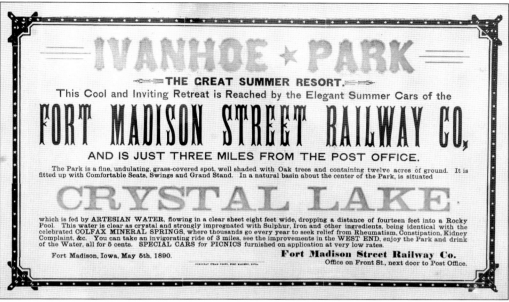

Established in 1887, Ivanhoe Park was not within the city limits. The trolley line ran from the east end of town and turned around in Ivanhoe, offering citizens an easy way to get to the west end. The park sported an artesian fountain and bandstand in 1888. It currently includes a rollerblade and skateboard park, baseball diamonds, and playground equipment.

Originally called Upper Public Square, Old Settlers Park is between Fourth and Fifth Streets and Avenues E and F. Pictured are members of the Old Settlers Association, which was started in 1870. Built in 1873, the octagonal bandstand later had an extension for speakers to use during meetings of the Old Settlers Association. Torn down in 1941, the bandstand was replaced by citizens in 1998.

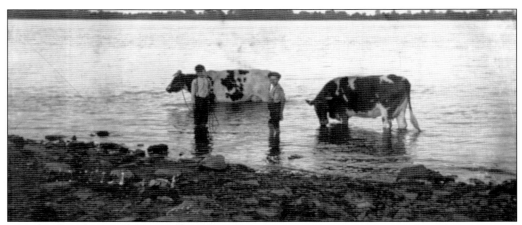

These cows being tended by two unidentified young boys seem content to wade in the Mississippi River. It was not uncommon to see livestock and animals of all kinds wandering the streets in Fort Madison. Perhaps this was what prompted Judge Phillip Viele to will a fund to erect a wooden fence around the Artesian Lake at Central Park.

Pictured are Dr. Eugene Watkins (left) and Frantz Hoenig, reenactors of the War of 1812. The men are on the historical battlefield site in the 400 block between Avenues G and H, where 22 men lost their lives. The War of 1812 Battlefield is on the National Historic Register. This battle was a turning point for the US Army. (Courtesy of Kathy Burkhardt.)

Pictured in the 1920s, this group poses at a celebration. Charlie Korschgen is in the center with the drum and wearing a bow tie. This bass drum has been in the Charlie Korschgen Fourth of July Kiddie Parade since 1948. Korschgen is credited with starting this parade in 1913. It is known as the oldest Fourth of July kiddie parade in the United States.

These young men are carrying flags for the Charlie Korschgen Fourth of July Kiddie Parade in 1954. Korschgen can be seen in the background carrying his drum. The parade route used to start at Twenty-Seventh Street and Avenue L and then turn at Eighteenth Street before heading back on Avenue H. It currently runs from Fifteenth Street to the 600 block on Avenue G.

Either Pauline or Louise Behrens is standing by the Lone Chimney Monument, a popular photographic opportunity back in the day. At left is W.A. Sheaffer Pen Company. After the burning of the original Fort Madison one chimney remained, and legend has it this was used as a landmark for riverboats coming around the bend. The replica Lone Chimney Monument was erected by the Jean Espy Chapter of the Daughters of the American Revolution in 1909 to commemorate the 100th anniversary of the 1808 military outpost. It was placed on an island in the middle of the road (its original location). The two cannons which flanked the monument were donated by the Rock Island Arsenal. Below, the chimney and cannons are being moved due to the construction of Highway 61 in 1951.

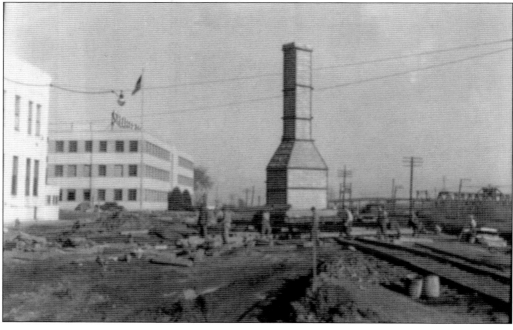

This parade was held on July 4, 1919. Marching along the 700 and 800 blocks of Avenue G is the 109th Ammo Train. These soldiers were from southeastern Iowa. Note the spectators marching with the men. Afterward, the men were sent to Camp Dodge in Johnston, Iowa, where they were subsequently discharged.

This is the famed 1873 Silsby Pumper being pulled by a team of horses in an undated parade photograph when Avenue G was still bricked. Note the smoke coming out of the still-operable pumper. This steam fire engine was used by the Fort Madison Fire Department to help put out several fires of import, including the 1911 fire that nearly destroyed the courthouse.

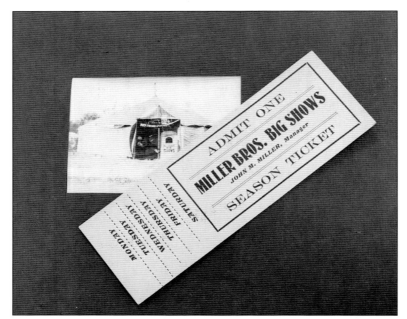

The lucky owner of this season ticket had admittance to the Miller Brothers Tent Show for a week. The Miller brothers, John and Charles (sons of Peter Miller), traveled and performed around the area for audiences as large as 1,200. Several family members performed with them, including John's wife, Ella, and daughter Anna. (Courtesy of Kathy Burkhardt.)

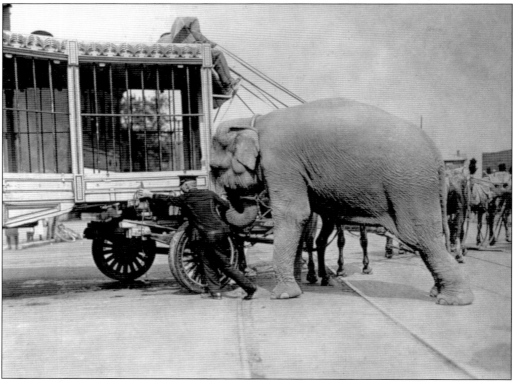

Several circuses have come to town over the years, the first having been the Hawes and Mable Circus in 1843, which included acrobats and horses. In 1850, the Mammoth Circus came, featuring four trained dogs. The Raymond Circus soon followed, boasting a rhinoceros. Many circuses visited the area, but none were as popular as the Ringling Brothers Circus of 1897, which included elephants.

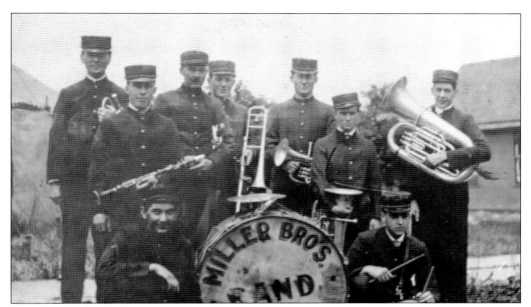

Fort Madison has had several bands over the last 150 years, including the Miller Brothers Band, above. The first municipal band, the Fort Madison Brass Band, was organized in the late 1850s by John A. Smith. For many years following, several bands competed for the honor of being known as the official city band. Eventually, the Fort Madison City Band held its first concert in 1930, being supported with public funds. Today, four concerts are held in June and July and are supported with private funds. The concerts have been held at the bandstand in Central Park since 1947. Seen here performing a 2017 Fourth of July Concert with Lisa Knipe directing *Salute to Armed Forces*, the band continues to entertain citizens today. (Right, courtesy of Krys Plate.)

Pictured from left to right are Isidra Borjas, Isabella Lozano-Dobbs, and Alexis Lozano-Dobbs, members of Fort Madison Fiesta Dance Troupe, ready to perform at the Mexican Fiesta in the early 1990s. One of the dances performed, Las Coronelas, is in honor of the women who fought in the Mexican Revolution. These young ladies are decked out in their handmade traditional Jalisco dresses made of several yards of colorful fabric and ribbon. (Courtesy of Sheri Lozano-Dobbs.)

The Dario and Anastasia Ruis family had six children: Carlos, Eleanor, Ralph, Salvador, Ophelia, and Robert. They lived at 3438 Avenue Q in the Mexican Village in the 1920s. They sold food at the Mexican Fiesta out of a homemade food stand in their yard. The fiesta, held on the third weekend of September, has been celebrating Mexico's independence from Spain for over 100 years. (Courtesy of Liza Hidalgo.)

Everyone's a cowboy on rodeo day. These unidentified men are recording the Rodeo Parade in front of the Fort Madison Savings Bank (636 Avenue G). Due to the large number of horses in the parade, several "pooper scooper" clowns are scattered throughout. The parade starts at the 2300 block of Avenue G and goes east.

The Tri-State Rodeo has been a fixture in Fort Madison since 1948 when Gene Autry agreed to make a performance stop with his rodeo on the way to Madison Square Gardens. A deal was struck to build the arena, and Autry held the rodeo here. The arena, now known as the C.E. "Eddie" Richards Arena, still hosts the rodeo. (Courtesy of Kathy Burkhardt.)

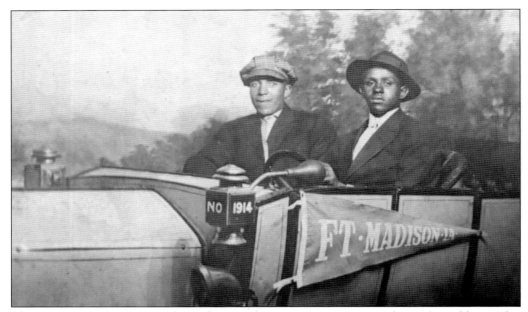

These young men are posing for a photographic opportunity in a mock-up of an old car. This was probably taken in 1914, as evidenced by the year on the car. Several photography studios in town had various scenes such as this. With the turn of the century came more diversity within the community, as people came to work as day laborers.

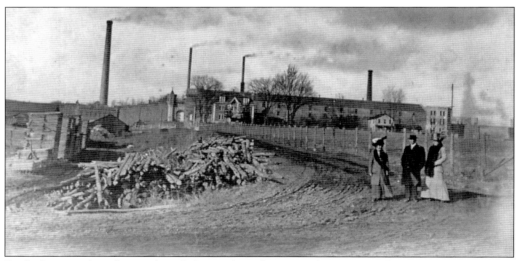

Decked out in their finery, these ladies and gentlemen are having a stroll near the Historic Iowa State Penitentiary. It appears that some construction of the wall behind them may have been going on. Note the warden's mansion in the background. This is the front side of the prison.

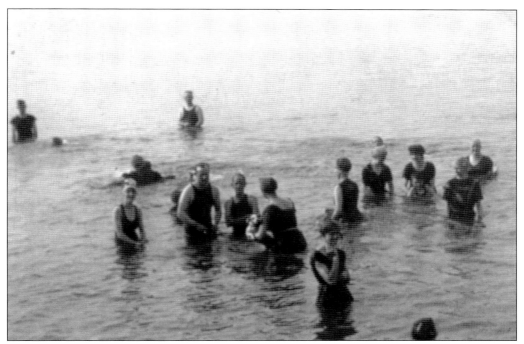

Back in the day, it was not uncommon to find people and their pets cooling off in any way they could during the hot summer months. These folks are enjoying a swim in the Mississippi River shallows. The river was within walking distance of most neighborhoods. Notice their dark swimming costumes and swimming caps.

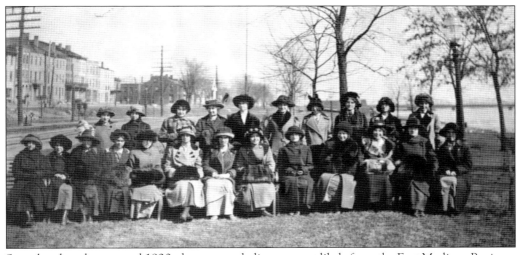

Seated on benches around 1920, these young ladies are most likely from the Fort Madison Business College, which operated from 1879 to 1948. They are in the 600 block of Front Street in Riverview Park. It must be a cold day, as they are wearing fur muffs. Note the bridge in the background.

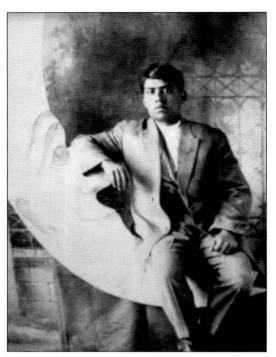

Augustin Lozano's family came to the United States in 1911. This is most likely Lozano posing at a local photography studio. The whimsical setting was a popular photographic opportunity. Lozano lived on Avenue P in the Mexican Village and worked at a grocery store. His brother, Alfredo Lozano, worked for the railroad. His descendants still live in the area today. (Courtesy of Angelo Lozano.)

This program from the Ebinger Grand Opera House was for the 1910–1911 season. The Ebinger was managed by Waldo Ebinger. Inside the program is listed the cast of *Bright Eyes*, with Cecil Lean and Florence Holbrook. Businesses advertised include Courtright Photography, Lindsey Tailoring Company, and Fort Madison Realty Company. The Pythian Printing Company advertised Ingersoll watches for $1.

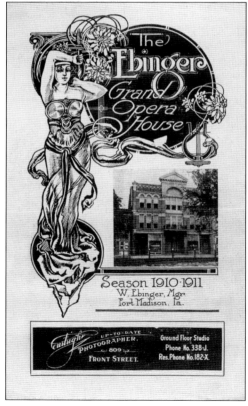

These 2013 RAGBRAI riders are taking a dip to cool off in the Mississippi River. The Register's Annual Great Bike Ride Across Iowa was started by the *Des Moines Register* in 1973 and still continues. Thousands of riders from around the world participate in this event. It starts at the Missouri River and ends on the bank of the Mississippi, with varying routes each year. The race has ended in Fort Madison several times. It is the largest bike ride in the world, with over 60,000 riders in 2023. The group below is sporting silly balloons on their helmets. Many squads adopt distinguishing decorations to help them be easily identified during the race. (Both, courtesy of Kathy Burkhardt.)

About the Organization

The North Lee County Historical Society was organized to preserve local and state history. Letters were sent to citizens to invite them to an organizational meeting, which was held in the ballroom of the Anthes Hotel at 8:00 p.m. on May 24, 1962. There were 24 people present, with Marg Fehseke presiding as temporary chairman. It was decided that dues would be $2 per year. Ted Werner was eventually elected as the first president. In July 1962, the society was incorporated. Included in the articles of incorporation were items such as marking historical sites, preserving public archives, and "to kindle and keep alive an active interest in state and local history."

The group's first project was the acquisition and restoration of Brush College. The land was leased from Clara Elizabeth Wenke for $2 per year for 20 years, while the schoolhouse was purchased from the Fort Madison Community School District for $1 in 1963.

As early as 1967, the group discussed finding a location for a museum. Santa Fe Railroad gave the Santa Fe Depot Complex to the city when train services were moved to the west end of town. The complex was leased to the society around 1971, with renovations beginning in about 1972. The museum opened in 1974.

Today, the organization has around 110 members and maintains the Historic 1812 Battlefield; Brush College; the Chicago, Burlington & Quincy Depot; the Old Lee County Jail; and the Santa Fe Depot Complex. Both depots house museums that can be visited daily. The historical society continues to preserve history through numerous volunteers and donations.

Index

Albers, Louis, 22, 23
Albright, Rachel, 96, 107
Amborn, Conrad J., 20, 60, 97, 109
Anthes Hotel, 28, 52, 127
Atlee, Isaac, 9, 12, 17, 54
Atlee, John Cox, 8, 9, 12, 25, 54
Atlee, Samuel, 12, 17, 69
Atlee, William Henry, 52, 98
August W. Richers Wood and Coal Company, 67
Beck, Joseph M., 8, 20, 97, 100
Benbow, Alfred, 13, 62, 109
Bennett, John, 39, 47, 49
Boss Hose Company No. 3, 22, 24
Casey, Sabert M., 11, 75
Cattermole, Caroline, 97, 105
Cattermole, Henry, 53, 60
Charlie Korschgen Fourth of July Kiddie Parade, 111, 115
Chief Black Hawk, 7, 14
Coger, Emma, 8
Corsepius, Ernest, 22, 51, 62
Dana Bushong Jewelry, 8, 51, 52, 66
Davis, Nola, 75, 79
Diamond Jo, 34, 36
Dodd Printing and Stationery, 8, 51, 57, 68
Doerr, Charles, 25, 101
Ebinger Grand Opera House, 30, 56
Eubank, Mollie, 9, 51
Faeth's Cigar Store, 51, 57
Galland, Eleanor, 21
Geiser, Dr. Mary, 51
Haessig, H.G., 61, 67, 70
Harper Apartments, 61
Harper, Dr. Harry, 38, 61
Herminghausen, Hattie, 11, 51, 60, 74, 98
Hesse, Bernard, 8, 18, 65, 97
Hesse Men's Clothier, 8, 51

Kasten, Dr. William, 17, 30
Kinglsey, Alpha, 7, 72
Kingsley Inn, 72, 73
Knapp, John Holly, 7, 9, 10, 63, 88, 103
Ladd, Amos, 9, 58, 65, 108
Lainson, Percy, 39, 48, 49
Lozano, Alfredo, 9, 124
Mexican Village, 81, 120, 124
Miller, Peter, 14, 118
Morrison, Dennis, 63, 69, 97, 101
Morrison, Joseph, 63, 69, 97, 99, 101
Morrison Plow Works, 10, 30, 63, 69, 99, 101
Rashid, Jacob, 12, 93
Reader, L.B., 61, 70
Ross, Betsy, 88, 107
Santa Fe Bridge, 25, 26
Santa Fe Depot, 28–30
Schlapp, August, 8, 18, 64
Soechtig, August, 8, 64
Troy Laundry, 72, 73
Viele, Phillip, 19, 114
W.A. Sheaffer Pen Company, 2, 27, 52, 65, 69, 101, 116
Wachtendorf, Patti, 39
Williams, Peter, 9

Discover Thousands of Local History Books
Featuring Millions of Vintage Images

Arcadia Publishing, the leading local history publisher in the United States, is committed to making history accessible and meaningful through publishing books that celebrate and preserve the heritage of America's people and places.

Find more books like this at
www.arcadiapublishing.com

Search for your hometown history, your old stomping grounds, and even your favorite sports team.

Consistent with our mission to preserve history on a local level, this book was printed in South Carolina on American-made paper and manufactured entirely in the United States. Products carrying the accredited Forest Stewardship Council (FSC) label are printed on 100 percent FSC-certified paper.